CARAVAN

Frances Lincoln Limited
74–77 White Lion Street
London N1 9PF
www.franceslincoln.com

A catalogue record for this book is available from
the British Library.

978-0-7112-3677-6

Printed and bound in China

1 2 3 4 5 6 7 8 9

FRANCES LINCOLN LIMITED

CARAVAN

A GREAT BRITISH LOVE STORY

GARETH IWAN JONES

FOREWORD BY JONATHAN MEADES

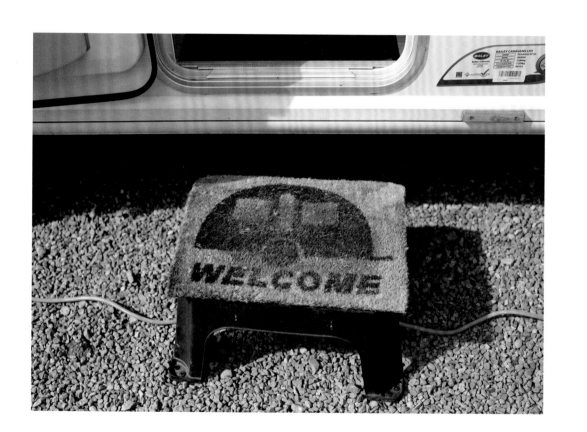

FOREWORD
JONATHAN MEADES

When in the mid 1990s I began to plan a film about caravans, I was rather ill-disposed towards what I called The Full Metal Carapace – snobbishly ill-disposed. But not without cause: I had as a child often stayed, against my will, in the caravan where my uncle and aunt lived, or subsisted, all the year round, on the scrappy southern edge of the New Forest. Elsan toilets smelled of privation as much as they did of shit and the supposedly cleansing chemicals that were olfactory assaults.

And as for my barmy, miserly, hypochondriacal, moralising uncle... had he owned a Tudor manor I'd have no doubt developed an animus against even the most splendid buildings of that period. I was haunted by the sound of rain's persistent drumming on the roof and the accretion of condensation on the windows and the cramped discomfort which prompted something near claustrophobia. And caravans' associative baggage was not felicitous. I had created some of that baggage: caravans are where porn dogs hang out; they are where doomed runaways go to the mattresses.

The actuality I discovered while researching the film was brighter, much brighter. Many caravanners turned out to be thoroughly eccentric and – astonishing given my uncle's mien – uncomplicatedly happy.

But then these are people who enthusiastically participate in such recondite pastimes as reversing competitions. I came to think of caravans as mobile analogues of beach huts, potting sheds, shacks at the bottom of the garden, wendy houses, even tree houses: play spaces, places that bring content.

One of the most engaging facets of Gareth Iwan Jones's work is the sureness with which he represents simple pleasures. There is a humanistic urge to share the relaxed happiness of his subjects. He speaks on their behalf. He seems to take a delight in people enjoying an undemanding hobby which might easily be mocked or patronised.

Good intentions are not, however, enough: this fondness would count for nothing without Jones's eye. Or eyes. An eye for (often comic) detail. An eye for counterintuitive framing. An eye for compositions that are oblique and suggestive. An eye for the peculiarities of the inanimate, for the kit that is specific to caravanning, banally familiar to caravanners and yet utterly mysterious to the rest of us. What is a commonplace form of recreation begins to take on an unthreatening strangeness, a jolly exoticism which says more about these islands than any number of joyless analyses.

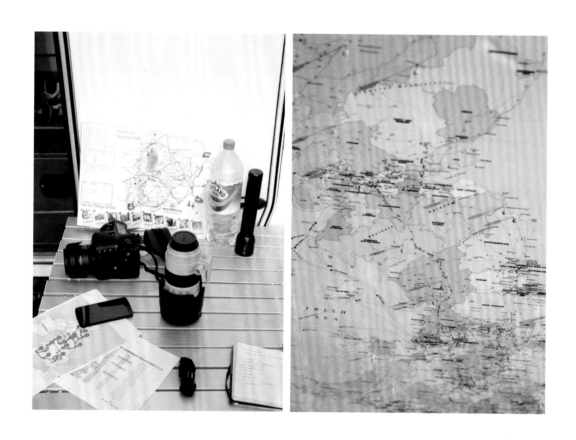

INTRODUCTION
GARETH IWAN JONES

Taking your accommodation with you on holiday is something Brits have done for more than a century. And like most well-established traditions, caravanning has its own unique set of practices, paraphernalia and patrons. Caravanners make up their own fascinating subculture, and that's what first attracted me to the idea of a photography project exploring the world of caravanning and the people who make it what it is.

I wanted this book to be partly a collection of portraiture and partly a documentary – I set out to illustrate why people love to caravan, as well as to go behind the scenes to capture an intimate take on the caravanning lifestyle.

The project reminded me of the holidays my parents took me on as a child. I remember watching my dad burn the sausages while my mum and I played cards and waited for the Southwold rain to stop battering our caravan. Burnt food and rain couldn't dampen our spirits. In fact, burnt food and rain just added to the back-to-basics charm of caravanning. The sense that our holiday was a challenge and an adventure would always override any downsides.

The trip I took for this book was even more challenging. Eight national parks, 27 caravan sites and 2,029 miles of road: I travelled the length and breadth of Great Britain in a cosy three-berth motorhome. Moving from pitch to pitch across the country, I was lucky enough to meet some brilliant people on my journey. I spent time with the families, couples and friends I photographed, and also experienced firsthand what makes caravanning special to people. There were lots of highs and not many lows. Even the realisation that I'd inherited my dad's ability to burn the sausages did little to hamper my enjoyment of the expedition. I'll never forget waking up in Glencoe in Scotland and looking out of the van window at some of the most beautiful mountain scenery I've ever seen.

At its most basic level, I think the enjoyment people seek from caravanning comes from wanting to dust off our little-used, but hard-wired, primary instincts. Our modern existence is so far removed from that of our ancestors and we seem to yearn to return to a low-tech life – even if it's just for a week.

It's not the easiest way to relax – there are obstacles to overcome at every turn – and even the morning expedition across cold wet fields to reach the shower block can feel like a triumph over adversity (once the mission is accomplished). But the rewards for sticking with it and embracing the challenge are numerous.

Beadnell Bay, Northumberland

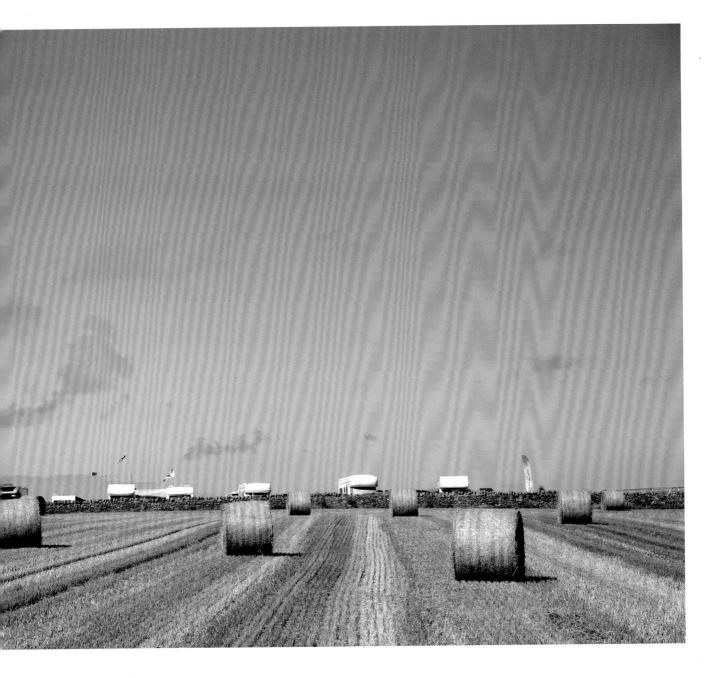

Berrow, Somerset

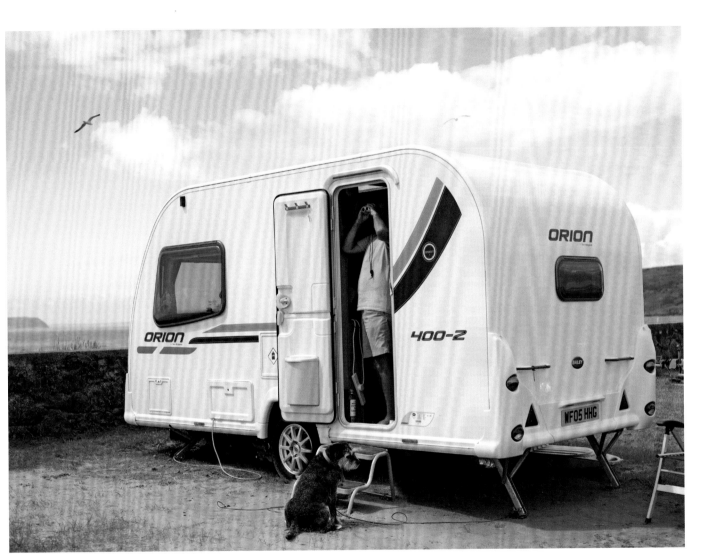

Shirley and Richard Lewis with Mia Lewis
Van life 30 minutes
Driving Bailey Ranger

'This is our first caravan holiday
– we've been here half an hour.
But I remember loving caravan
holidays in Tenby as a child, and
now I get to recreate that for our
granddaughter. She's only five,
but we got her a mini version of
my camping chair and camping
equipment so she has her own
set of everything.'
Shirley

Brean Sands, Somerset

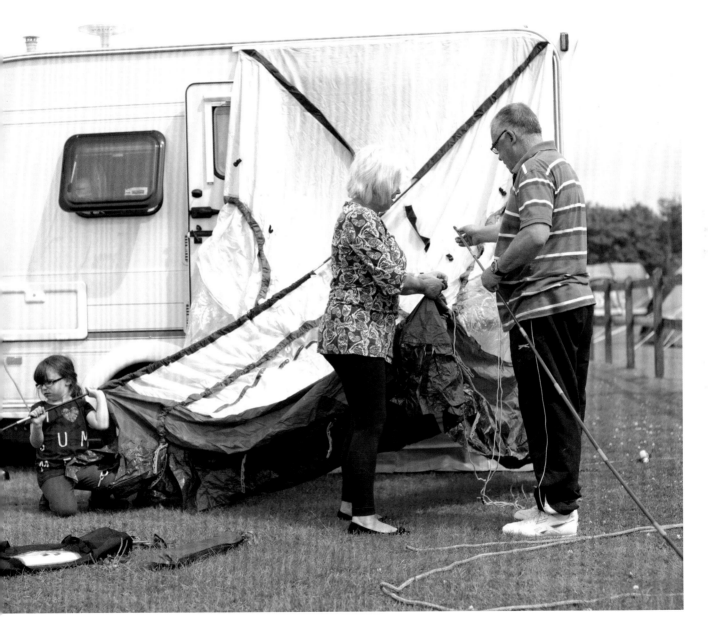

St Neots, Cambridgeshire

Oban, Argyll

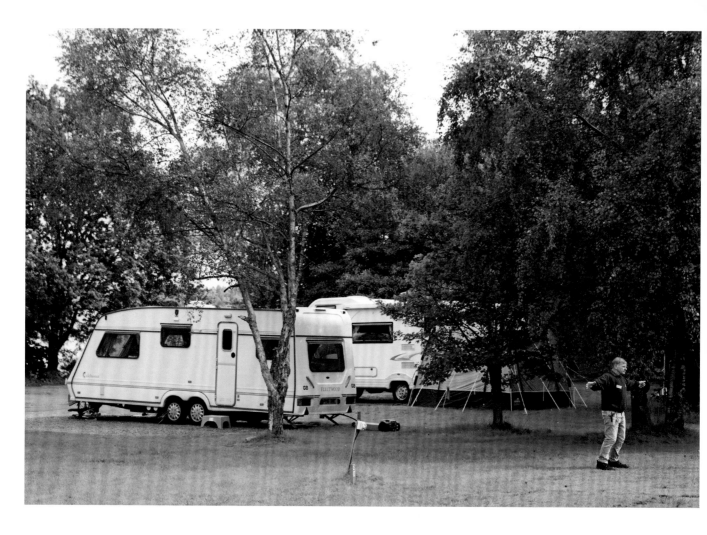

Luss, Loch Lomond

Mike Atkinson
Van life 13 years
Driving Compass Drifter 310

'We start our holiday by driving
to the end of our street and turning
left for Scotland.'

Foyers, Loch Ness

Scarborough, Yorkshire

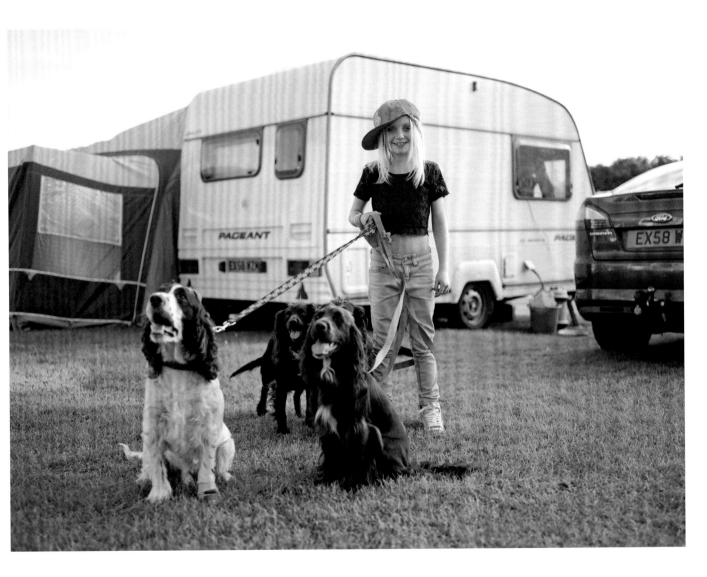

Kelvedon Hatch, Essex

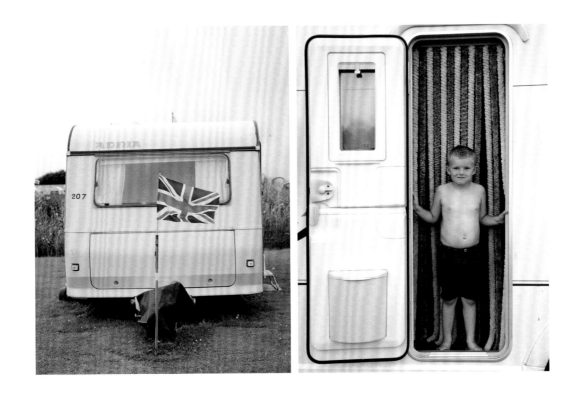

Devizes, Wiltshire

Lisa and Isobel Edwards
Van life 3 years
Driving Constructam Comet

'We bought this van on eBay from a Glastonbury hippie. We call her Connie the Comet.'

Lisa

Beadnell Bay, Northumberland

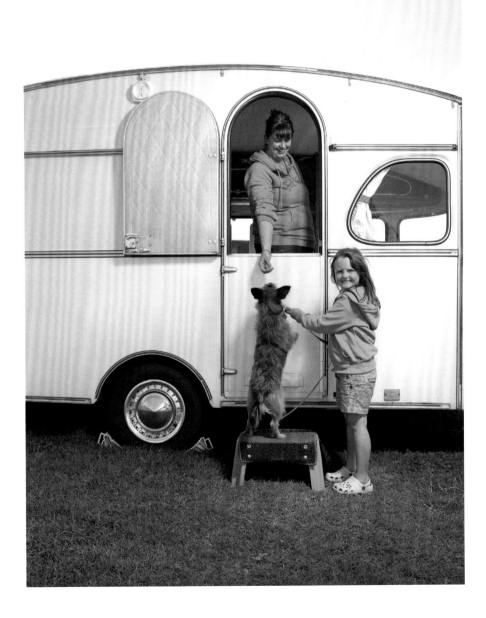

Walton-on-Thames, Surrey

Glencoe, Argyll

Courtney Lester
Van life Less than a year
Driving Knaus 700 LEG

'Our essential caravanning kit is alcohol. And we don't go anywhere without board games. Tonight we're playing charades.'

Beddgelert, Snowdonia

Walton-on-Thames, Surrey

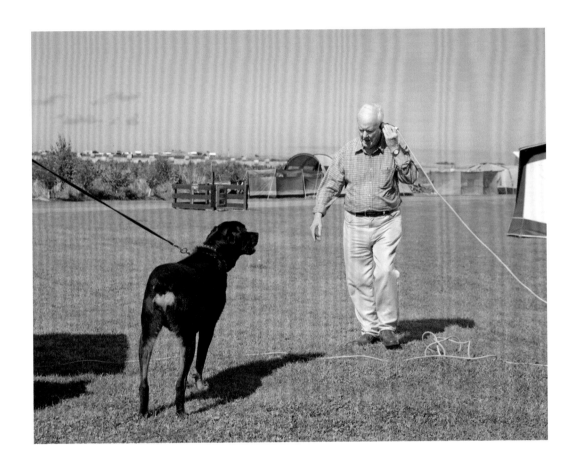

Beadnell Bay, Northumberland

Brean Sands, Somerset

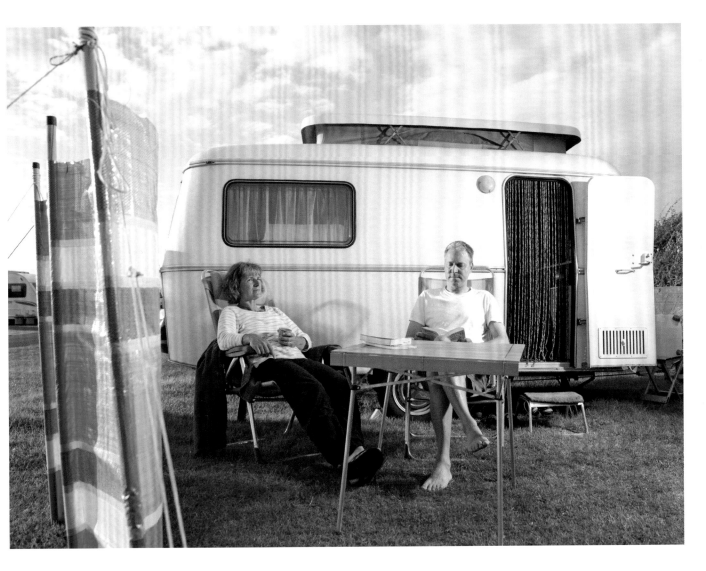

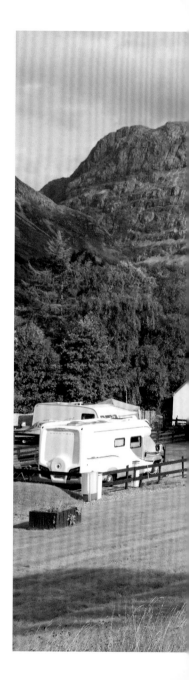

Glencoe, Argyll

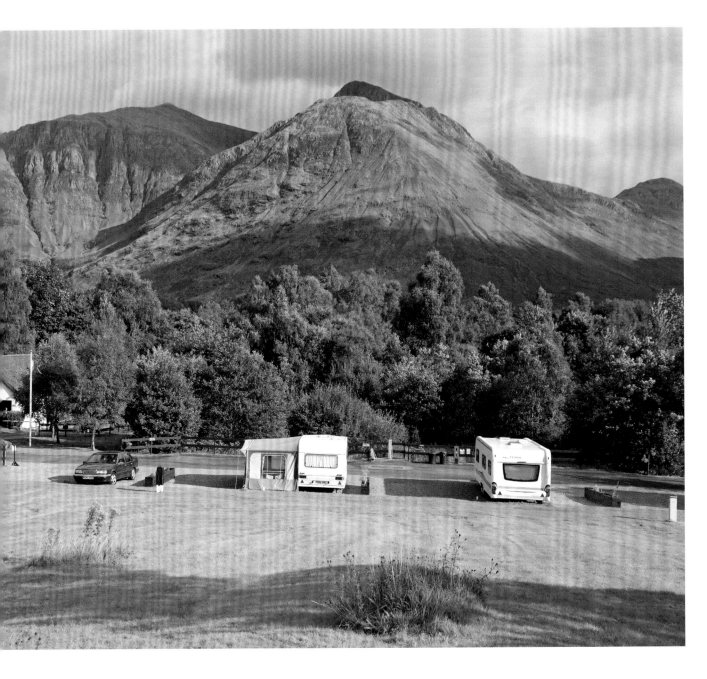

Jenny and Stuart Airey
Van life 58 years
Driving Swift Challenger 620

'The seed of love was sown when I was just a boy Scout, camping in the Lake District. You need a certain temperament to be a caravanner. And an awning. And a table-top freezer. And a tandem bike. We tandem-biked around the lake today. It takes us a while because we mess about and stop for picnics.'

Geoff

Keswick, Lake District

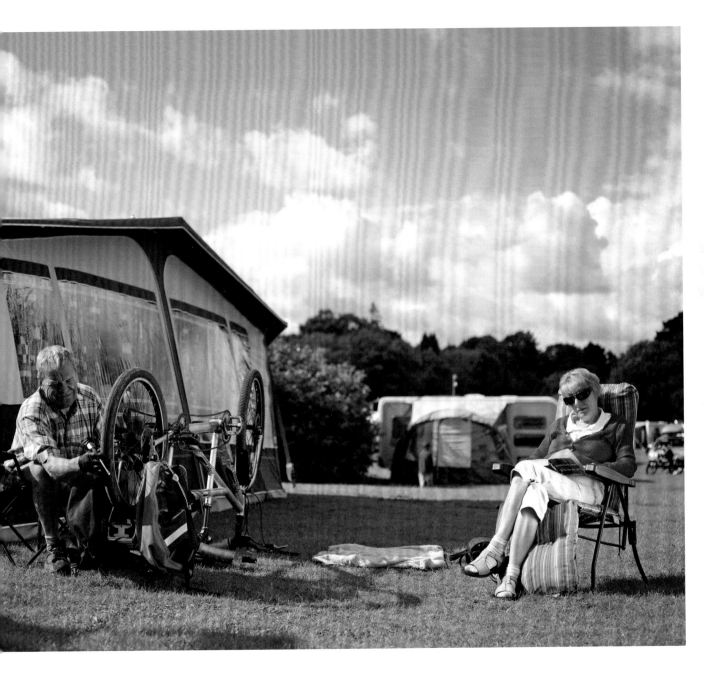

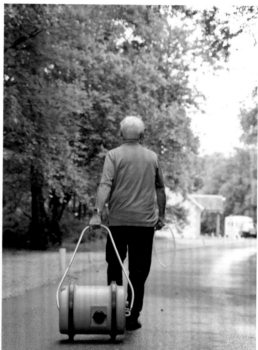

Luss, Loch Lomond

Teign Valley, Dartmoor

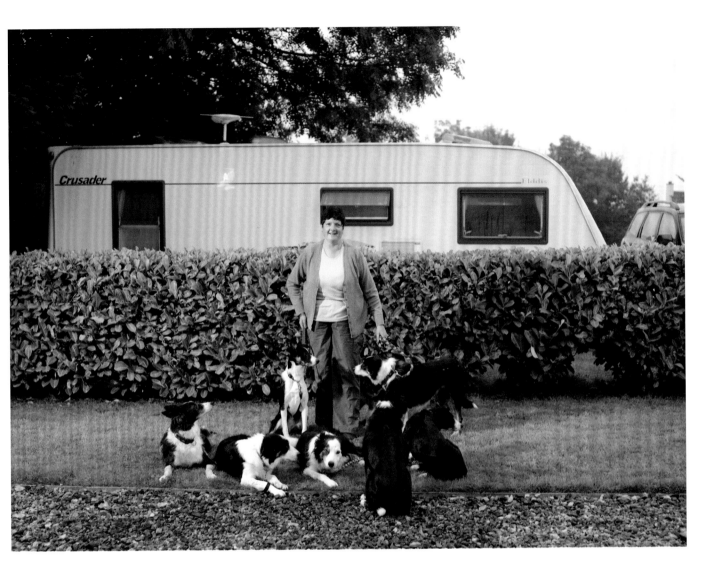

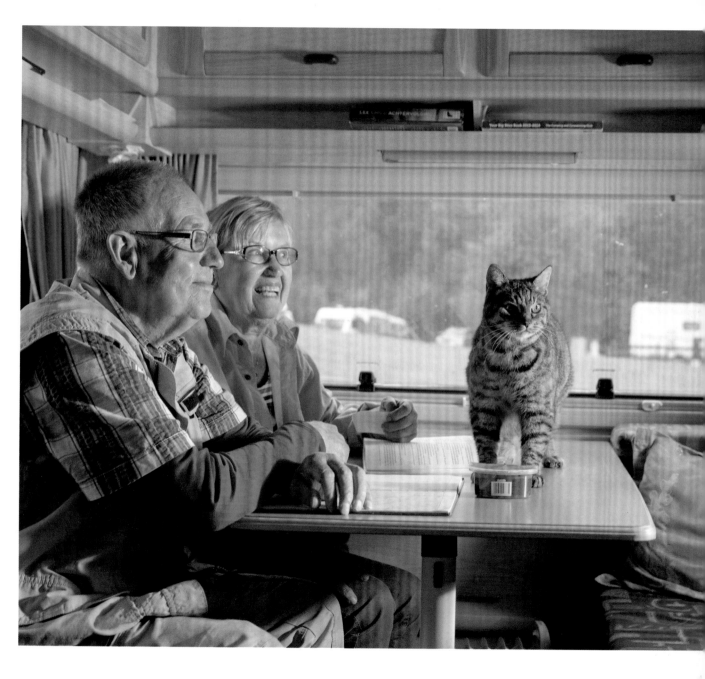

Jan and Albertje Huitema
Van life 35 years
Driving Biod 420

'The cat is essential to our holidays.
And you can't take her to a hotel.
This is like a private hotel on wheels.
We don't book, we just arrive.'

Albertje

Glencoe, Argyll

Braithwaite Fold, Lake District

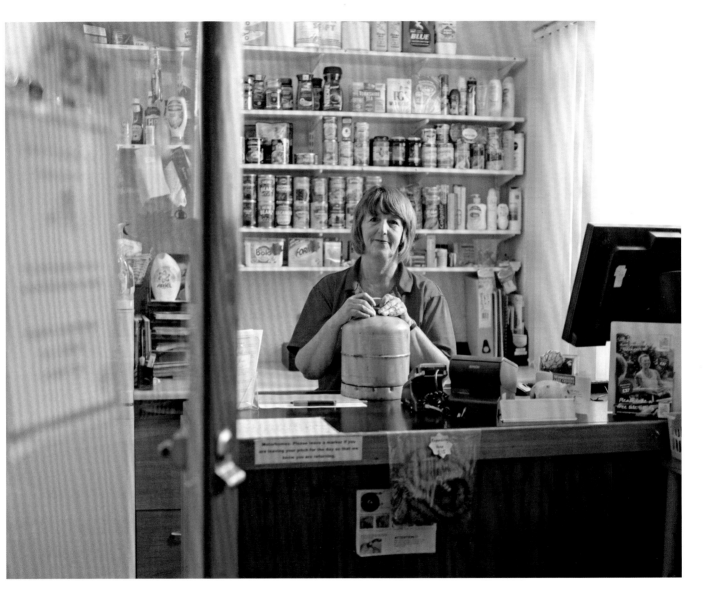

Milarrochy Bay, Loch Lomond

Delamere Forest, Cheshire

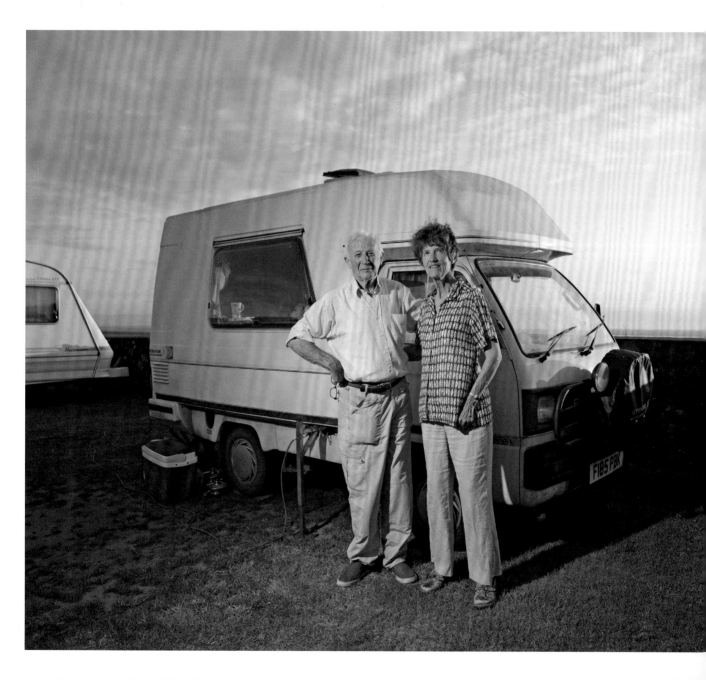

John and Helen Lewis
Van life 52 years
Driving A converted Bedford Rascal

'We had our honeymoon in a
caravan back in 1962. And we're
as happy in our van now as we
were then. It's a spontaneous
sort of holiday. We decided last
night that we'd come away for the
weekend, and here we are. All you
need is some sardines, baked beans
and biscuits for the dog.'

John

Brean Sands, Somerset

Keswick, Lake District

Rhandirmwyn, Carmarthenshire

Windermere, Lake District

Mark, Claire and Jessica Connelly
Van life 2 years
Driving Giest Aktiv

'Just don't forget the teabags.
Or waterproofs. Or patience.'

Claire

Luss, Loch Lomond

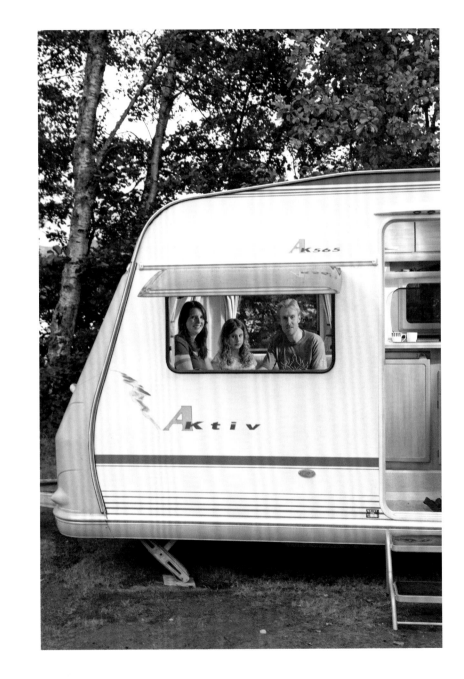

Devizes, Wiltshire

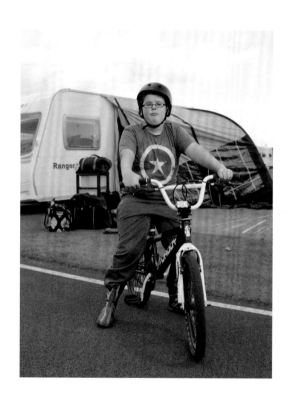

Scarborough, Yorkshire

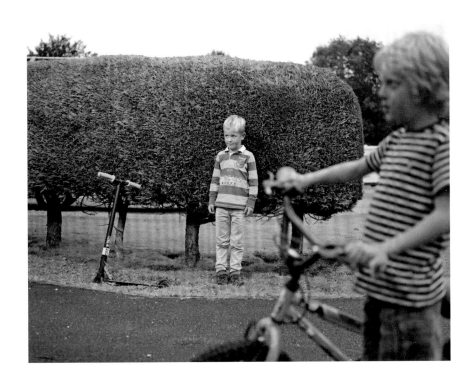

Windermere, Lake District

Elaine and Drew Sneddon
Van life 40 years
Driving Swift Jura

'I remember looking out over
the water to the hills of Malvern.
The sun was shining, the weather
was glorious.'
Elaine

Glencoe, Argyll

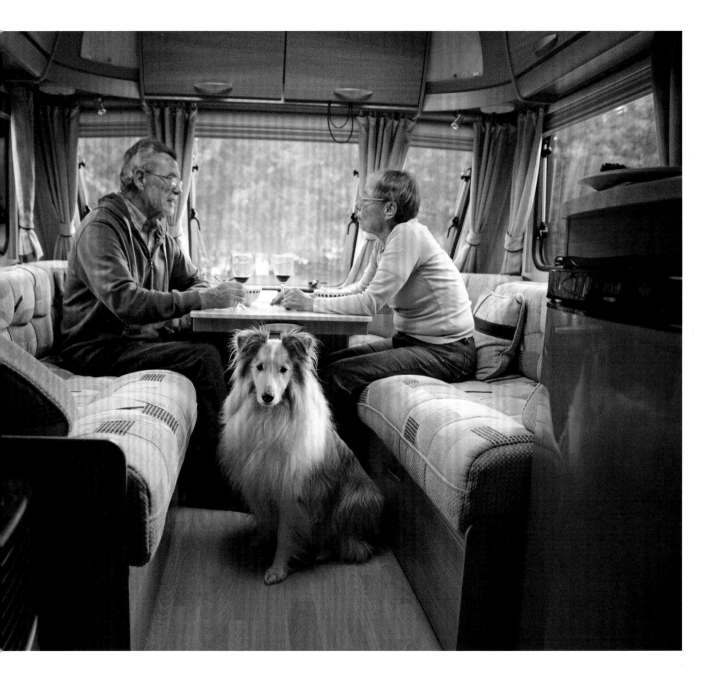

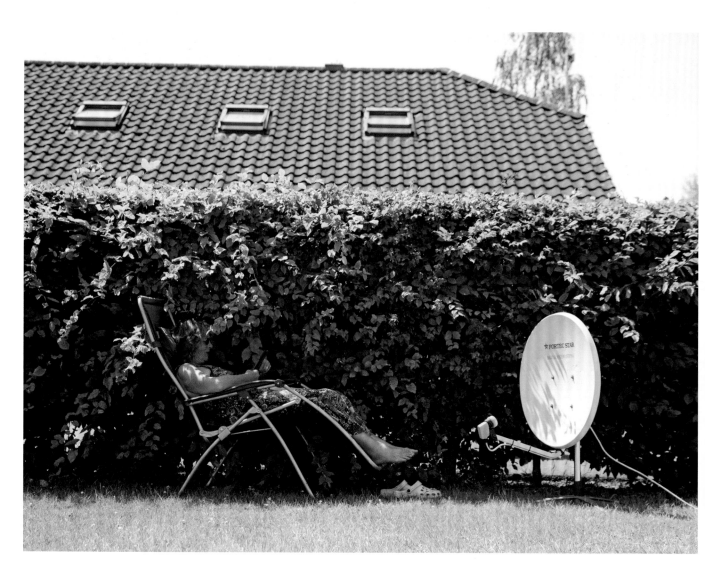

Devizes, Wiltshire

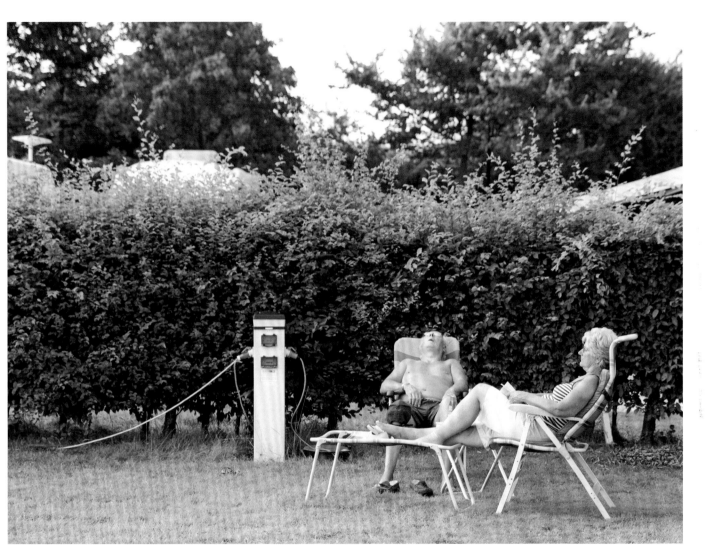

Lauder, Scottish Borders

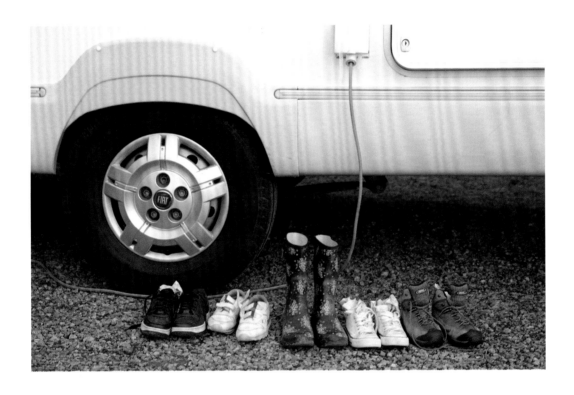

Ocknell, New Forest

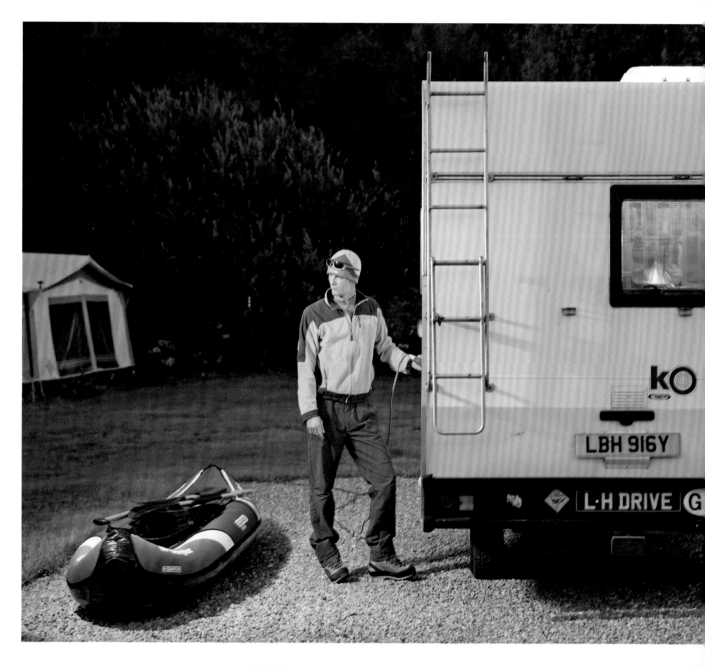

Aidan Taylor
Van life 3 years
Driving Toyota HiAce with Karmann Reisemobile

'Me and my girlfriend bought this van off my brother. It's always falling apart – you shouldn't do business with family. We loved going to the south of France though. The fridge barely worked, there was no air-con – but that was part of the experience. Not knowing if the ice-lollies would still be ice when we got back was what made it fun.'

Glenmore, Cairngorms

Brean Sands, Somerset

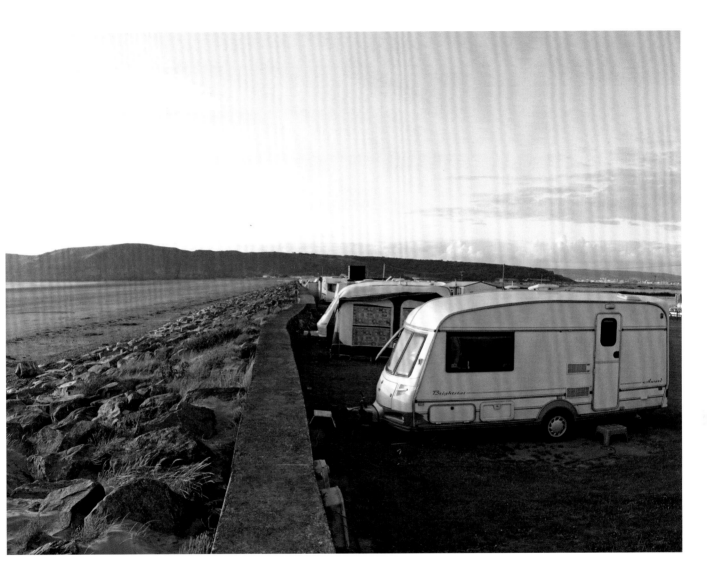

Berrow, Somerset

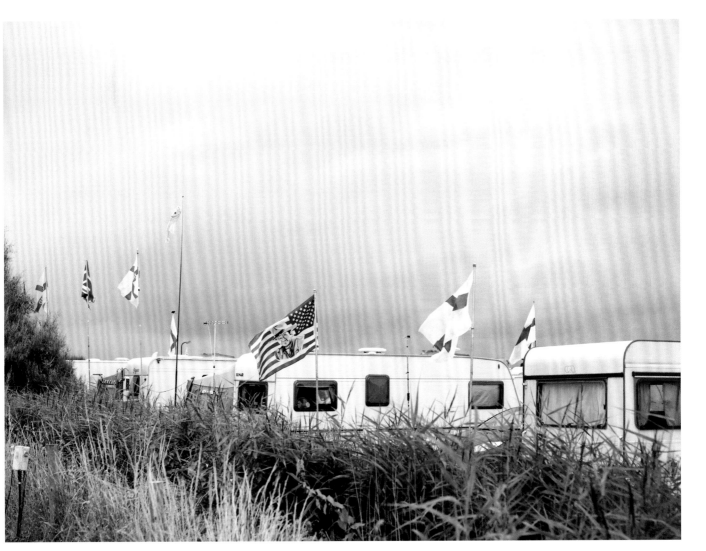

Alan Cobb
Van life 78 years
Driving Eriba Pan Familia

'I always bring plenty of whisky.
And a good attitude. You have to
embrace the weather: when I got
snowed in at Cowden last year,
robins flew into the caravan to
say hello.'

Foyers, Loch Ness

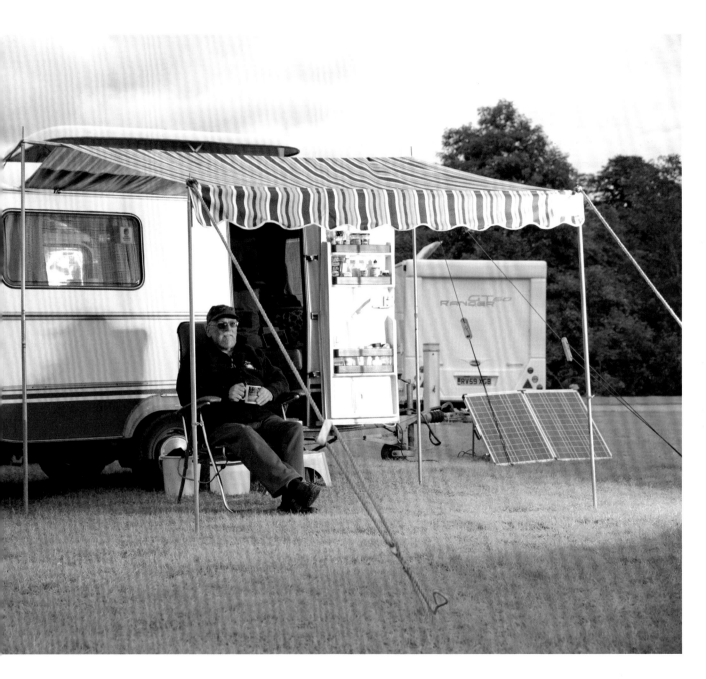

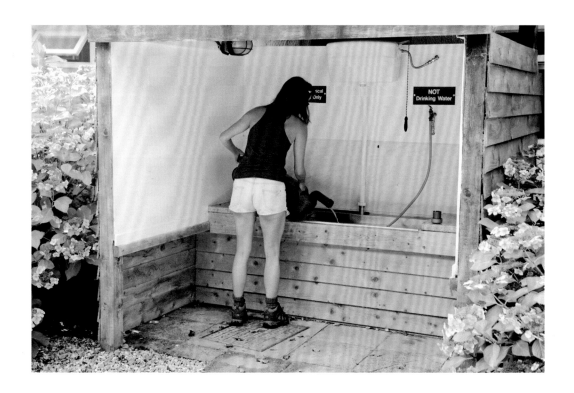

Teign Valley, Dartmoor

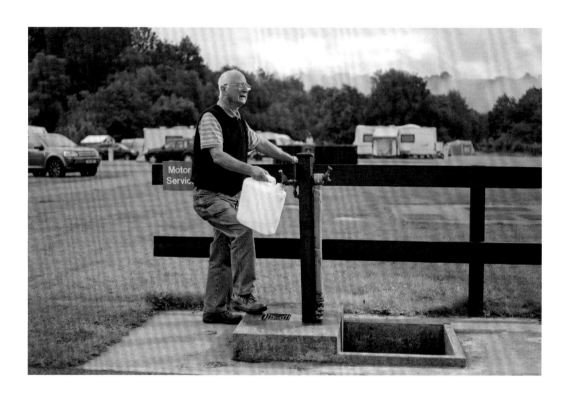

Rhandirmwyn, Carmarthenshire

Kelvedon Hatch, Essex

St Neots, Cambridgeshire

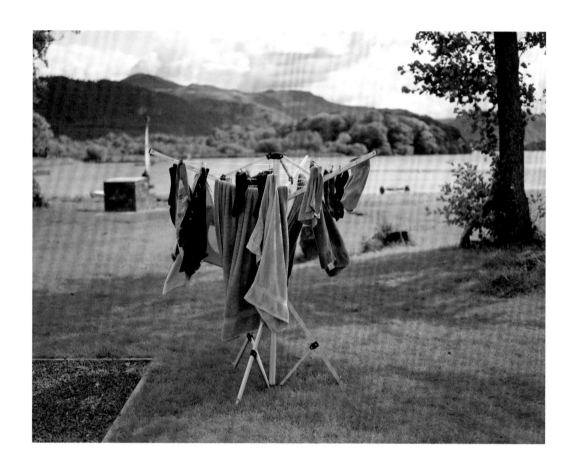

Keswick, Lake District

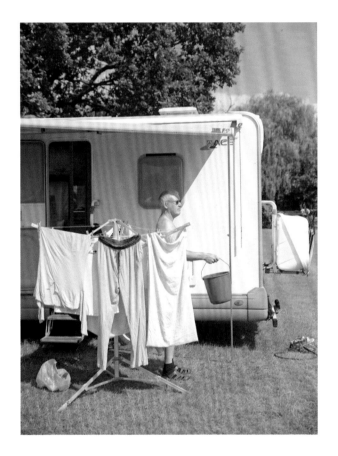

Walton-on-Thames, Surrey

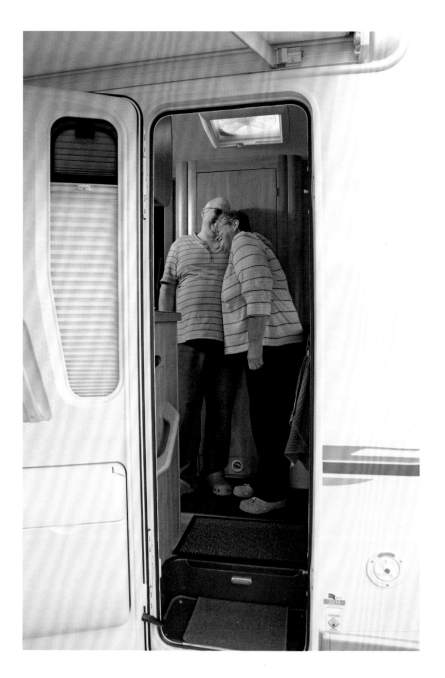

Maureen and Brian Gillies
Van life 43 years
Driving Auto-Trail Navajo

'We've been caravanning since we met. Our only essential kit is each other – as long as we're together, that's all we need. For our fortieth anniversary our daughter made a cake that was a replica of us with our van – the attention to detail was incredible. We're known for taking the rough with the smooth. A farm wagon once sprayed us with manure and the van was soaked in it. We stunk for weeks. But then we went to Glen Brittle on Skye for a day and it was so beautiful we stayed for two weeks.'

Maureen

Foyers, Loch Ness

 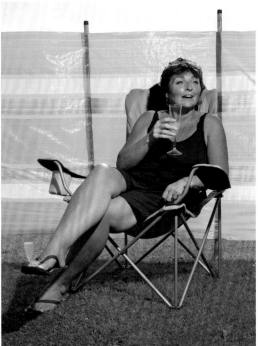

Glenmore, Cairngorms, and Brean Sands, Somerset

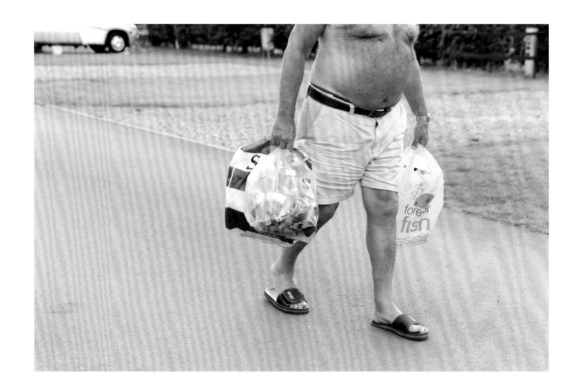

Devizes, Wiltshire

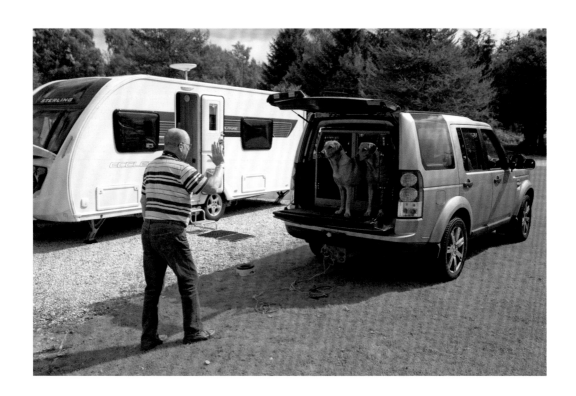

Windermere, Lake District

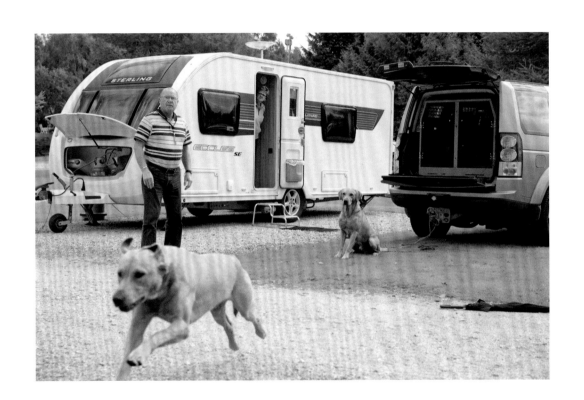

Keswick, Lake District

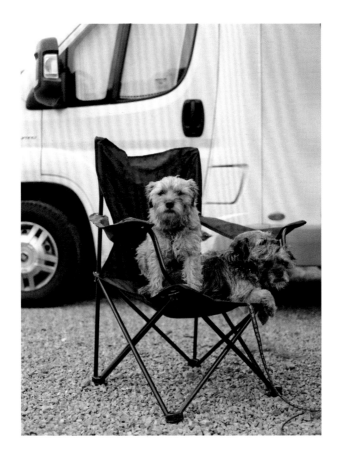

Rhandirmwyn, Carmarthenshire

Ann and Alan Gregg
Van life 1 year
Driving Bailey Pegasus GT65

'It's about fresh air and freedom.
And not having to worry about
hotel breakfast times.'

Ann

Oban, Argyll

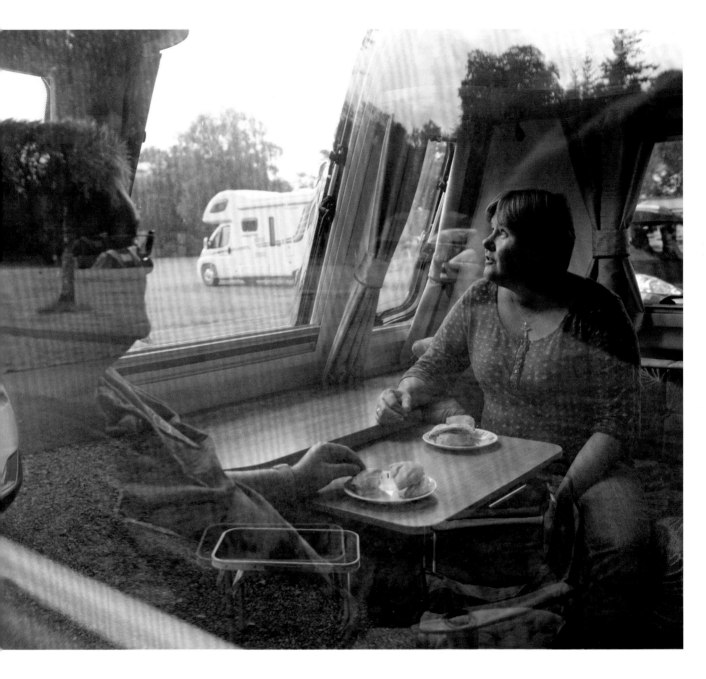

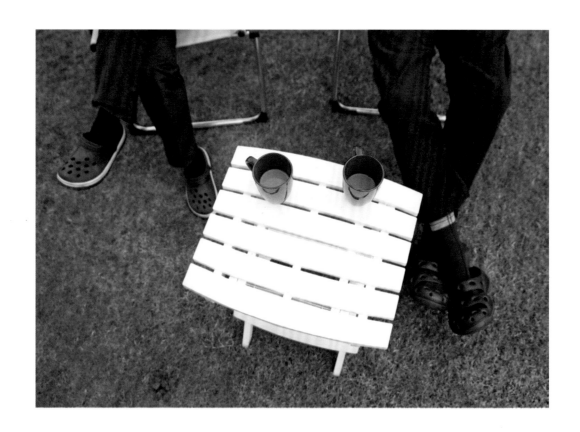

Lauder, Scottish Borders

Delamere Forest, Cheshire

Lauder, Scottish Borders

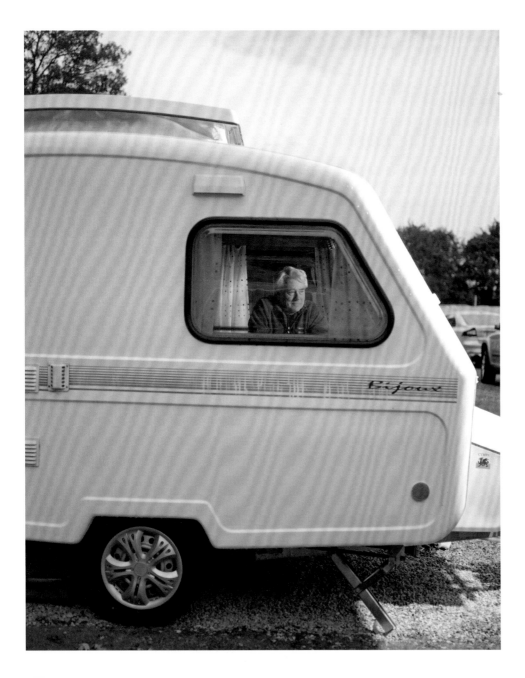

Neil Williams
Van life 40 years
Driving Freedom Bijoux

'Over the years, caravanning has become part of my life. It gives me the freedom to do what I want, when I want.'

Braithwaite Fold, Lake District

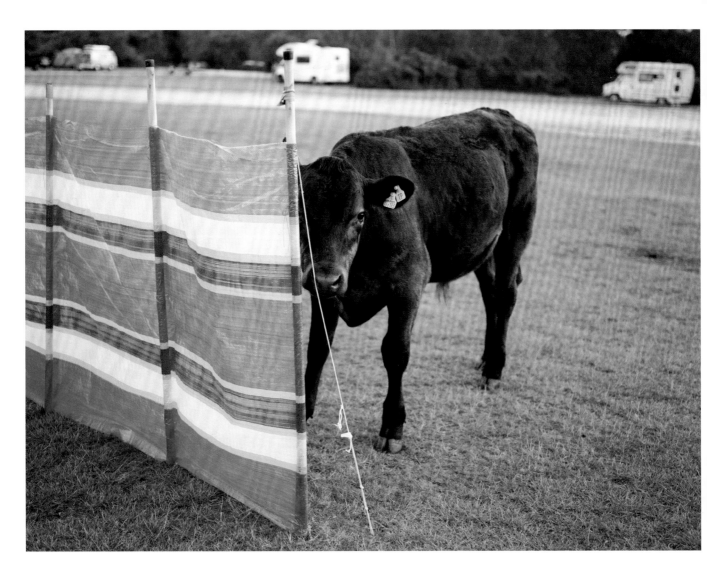

Ocknell, New Forest

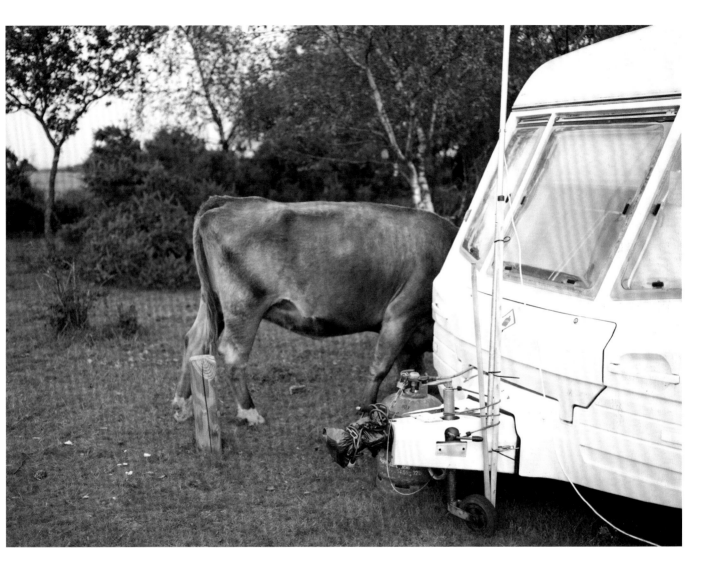

St Neots, Cambridgeshire

Michael Bradley
Van life 10 years
Driving Eriba Puck 120 GT

'Five years ago I had a beautiful
blue budgie. The wind knocked
over the cage and he flew away.
That was Joey. These two I have
now are also called Joey. I go off
walking, come back, have a cup
of tea and watch telly. What more
could you want?'

Kelvedon Hatch, Essex

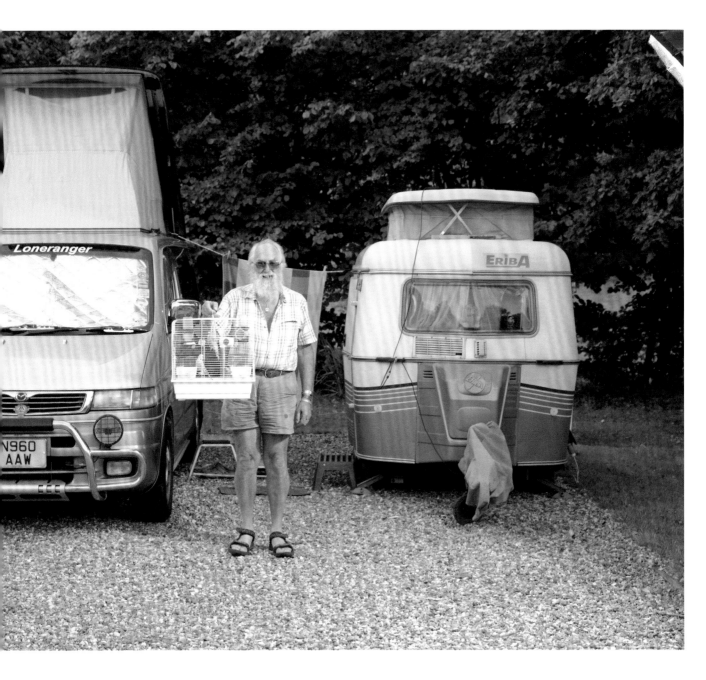

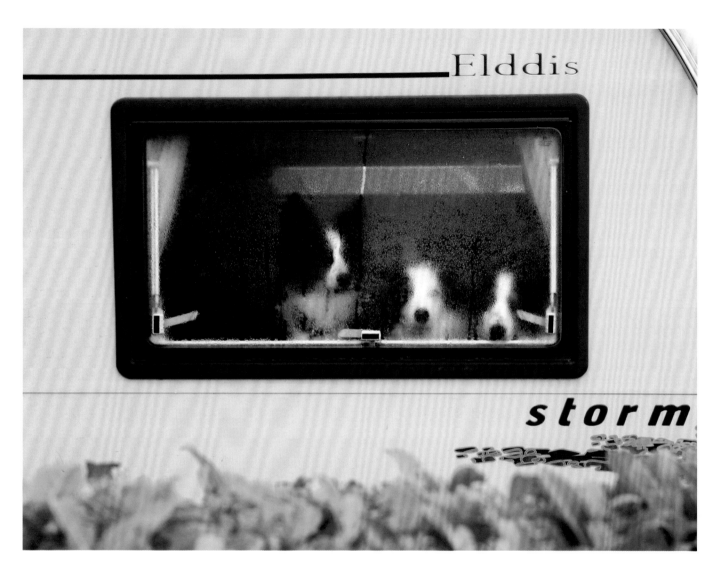

Teign Valley, Dartmoor

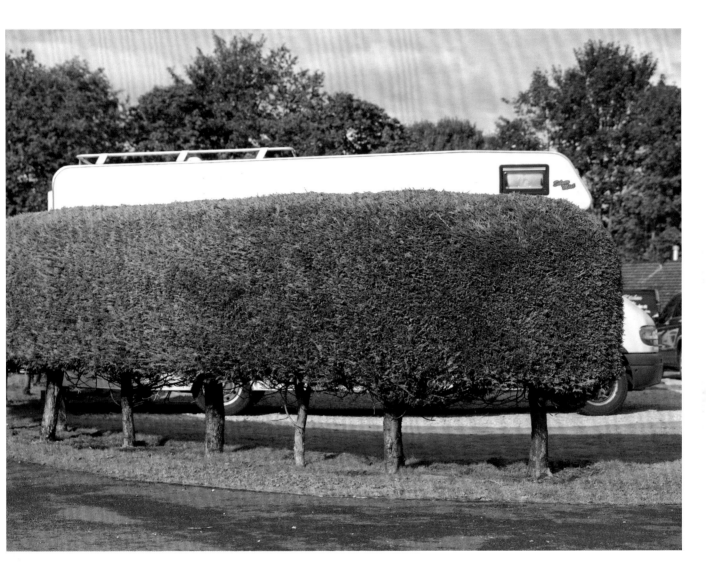

Windermere, Lake District

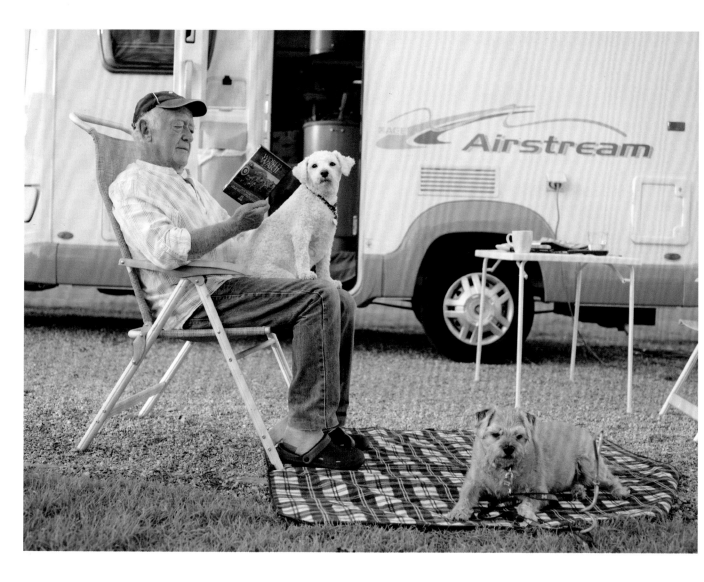

St Neots, Cambridgeshire

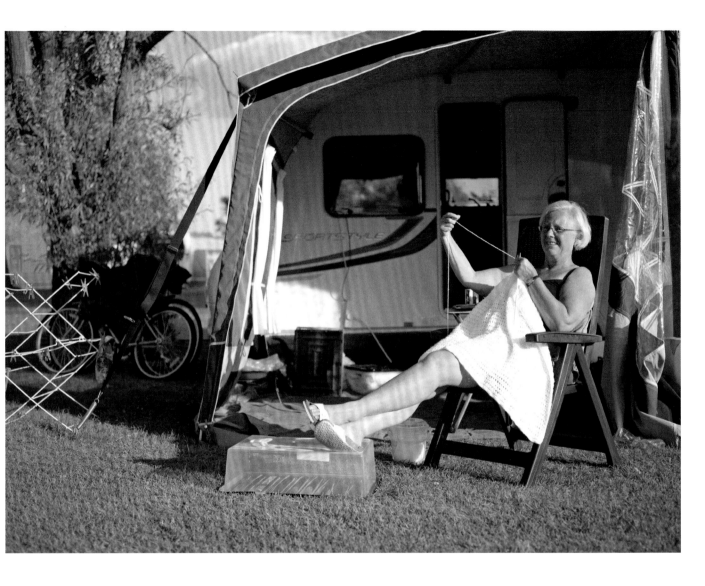

Jackie, Julian, Josie and James Davies
Van life 9 years
Driving Bailey Pageant

'Seven years ago, there was a
hurricane and we had to run out
in the middle of the night with
no clothes on and hold down
the awning. We learn as we go
– now the awning is held down
by storm straps.'

Julian

Glencoe, Argyll

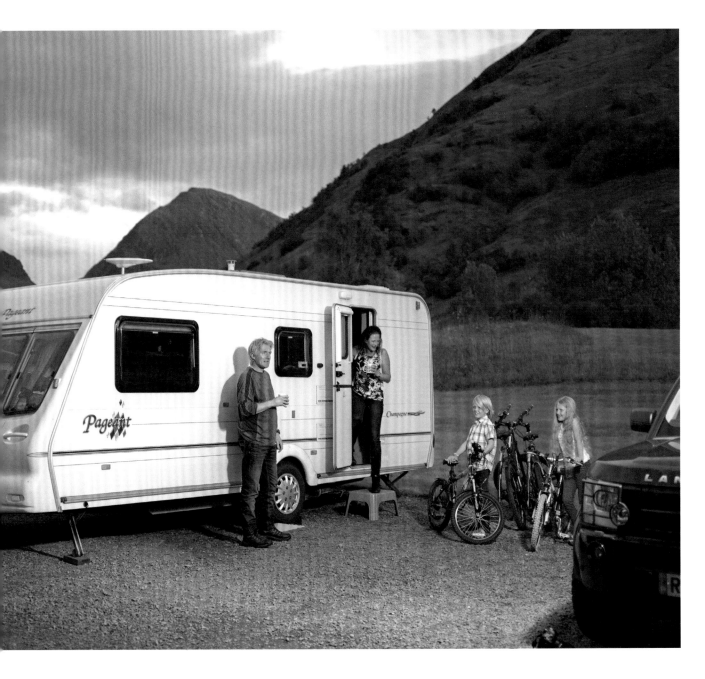

Glencoe, Argyll

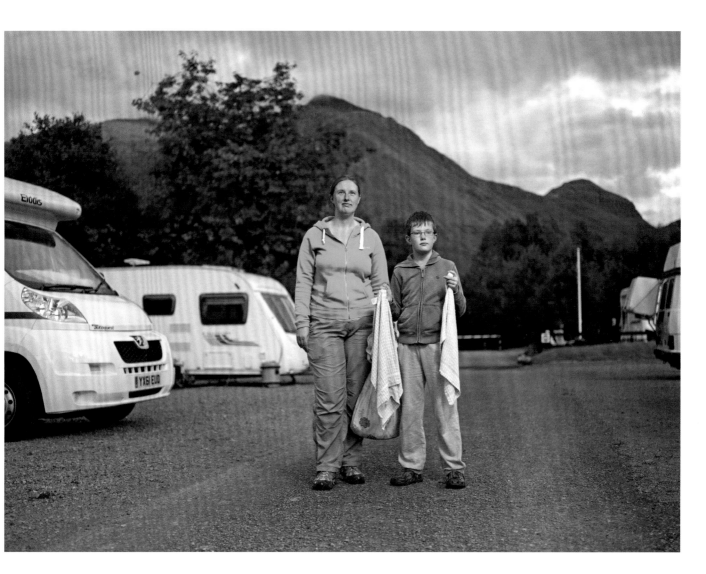

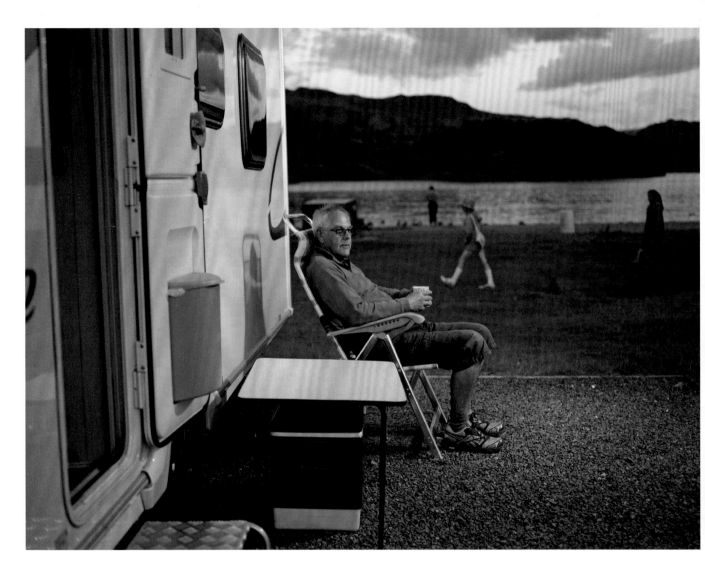

Keswick, Lake District

Ray and Jenny Ringe
Van life 22 years
Driving Sterling Eccles Quartz

'If I'm at home, I can only sit down
for five minutes before I think
of something I need to do. Here,
I just relax. Our grandkids see
the same friends year after year.
And where else can you leave
all your goods unlocked without
them getting stolen?'

Ray

Keswick, Lake District

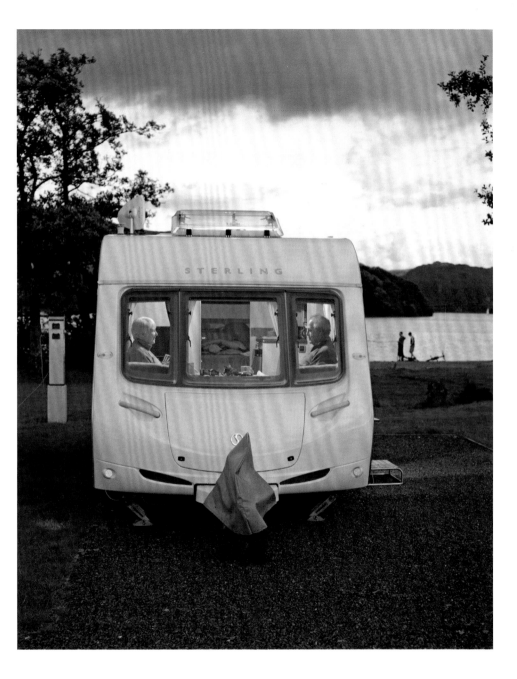

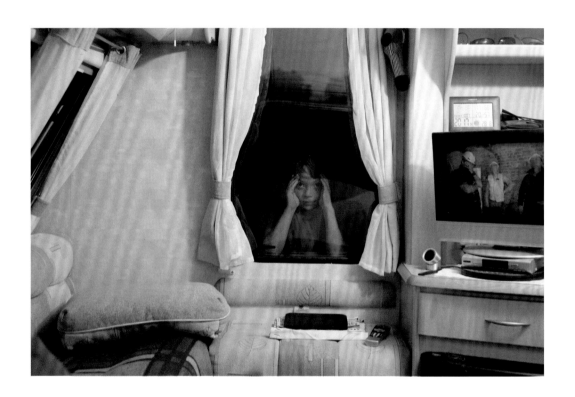

Scarborough, Yorkshire

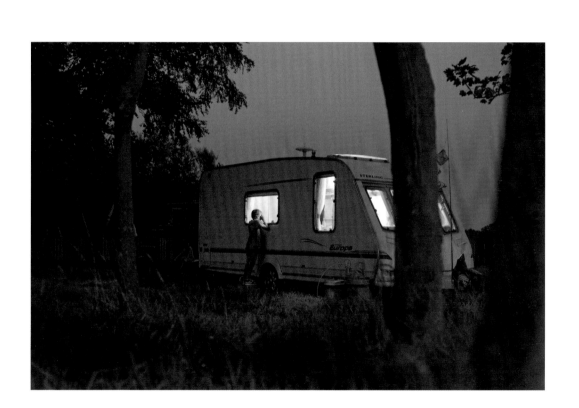

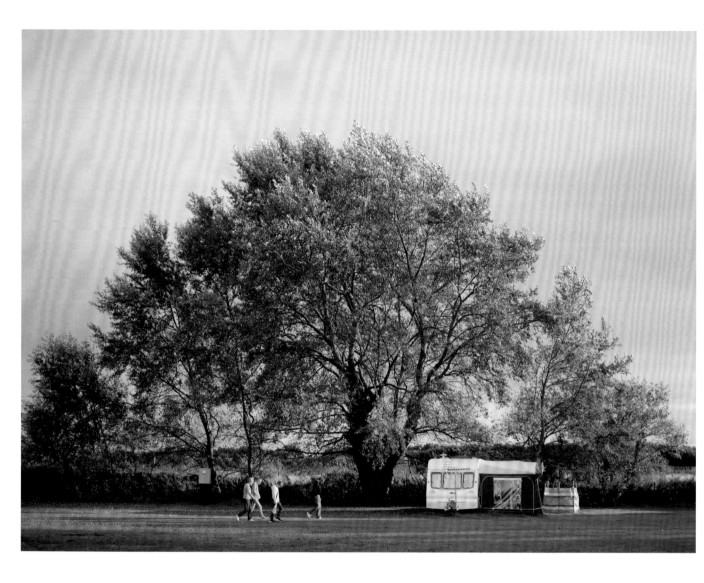

St Neots, Cambridgeshire

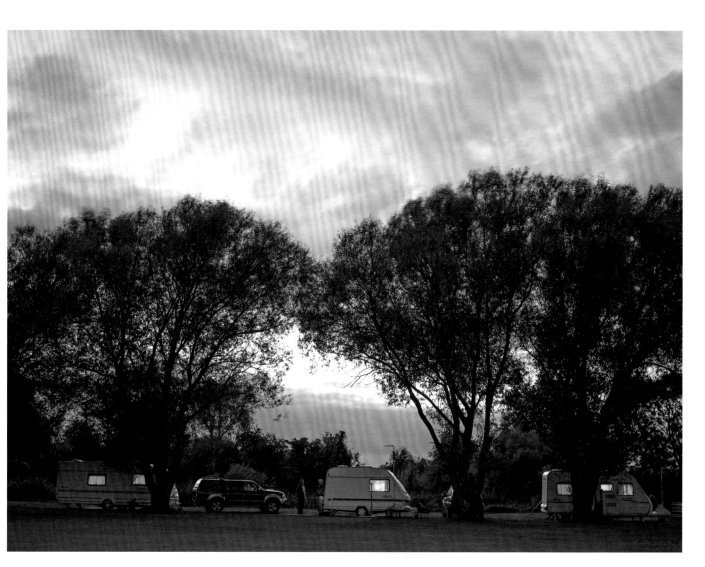

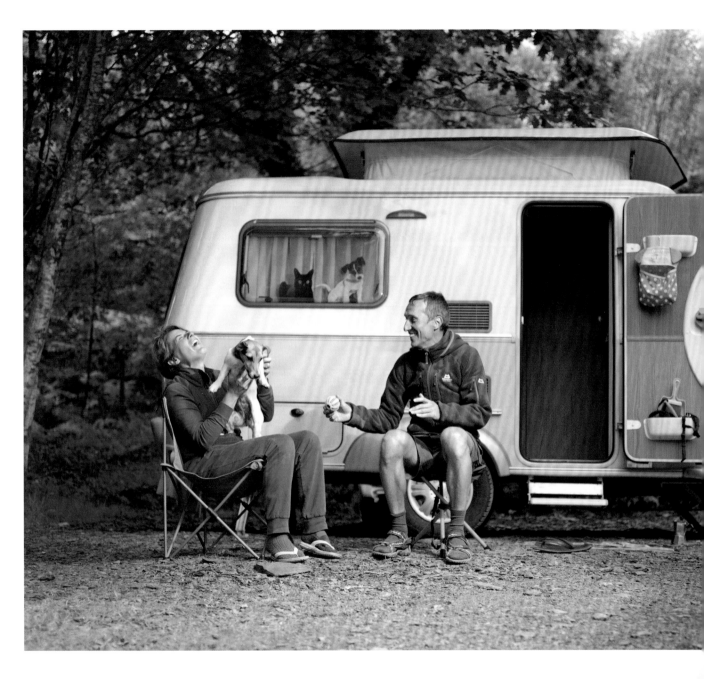

Elene Margrita and Fabio Bruno
Van life 2 years
Driving Eriba Hymer

'We can't go on the road without Minnie, our dog.'

Fabio

Beddgelert, Snowdonia

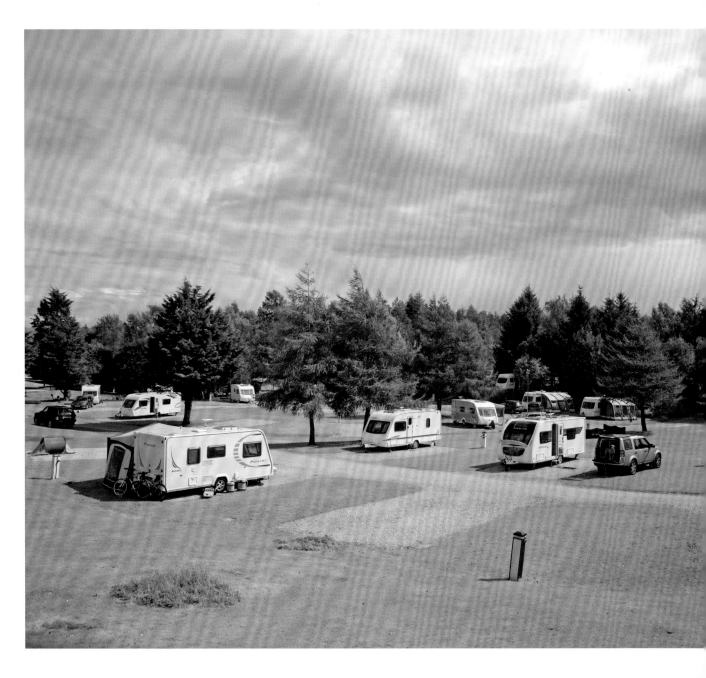

Windermere, Lake District

St Neots, Cambridgeshire

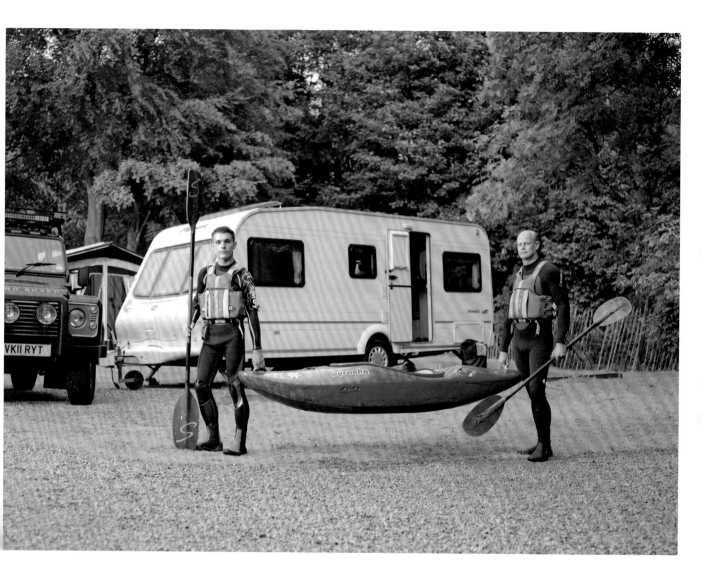

Braithwaite Fold, Lake District

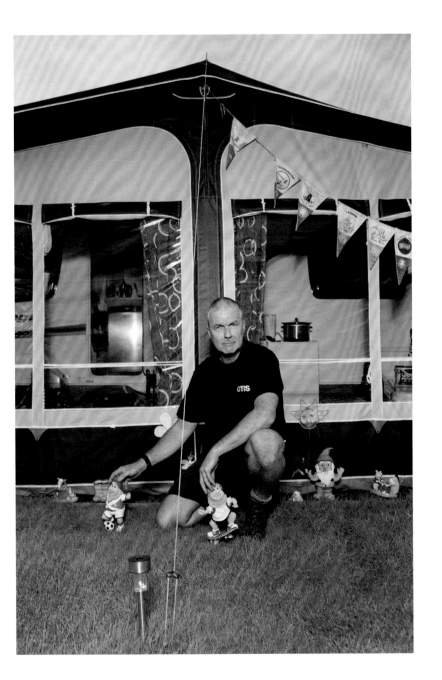

John Scott
Van life 20 years
Driving Swift Challenger

'When the kids were small, carvanning was such an easy and safe holiday – they could run riot. Everyone knows each other's kids, everyone looks out for each other's kids.'

Lauder, Scottish Borders

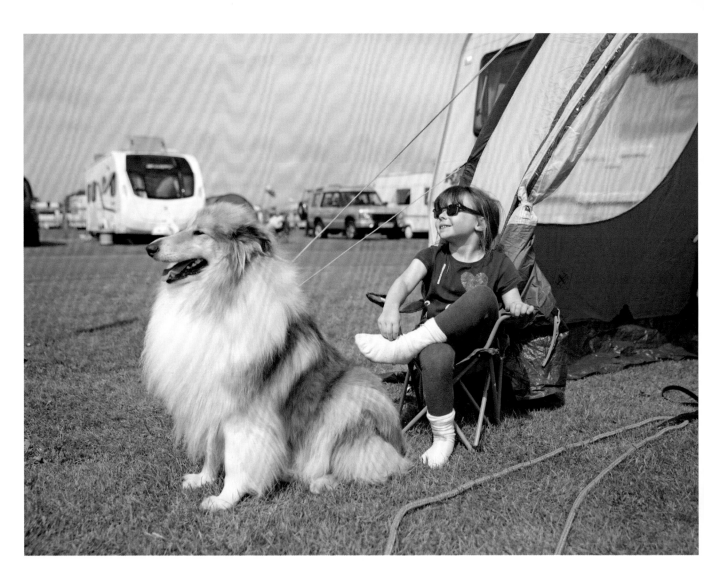

Brean Sands, Somerset

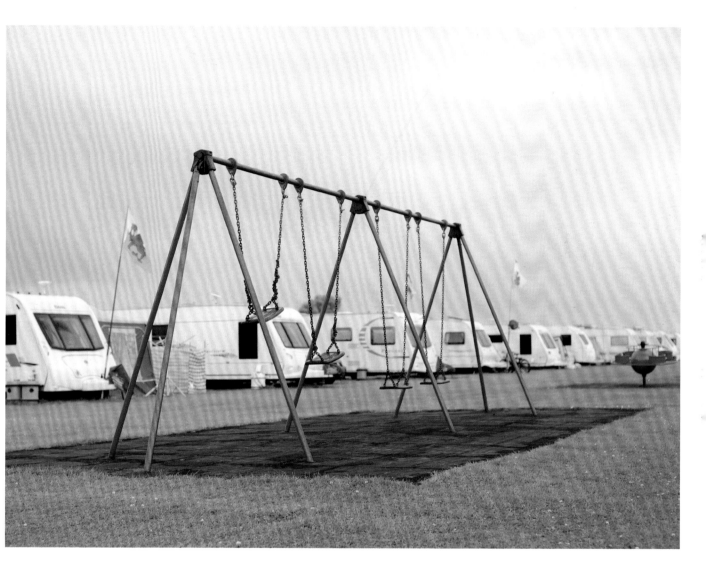

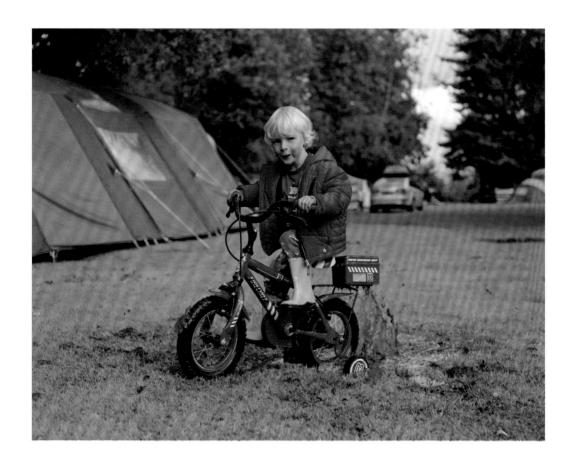

Luss, Loch Lomond

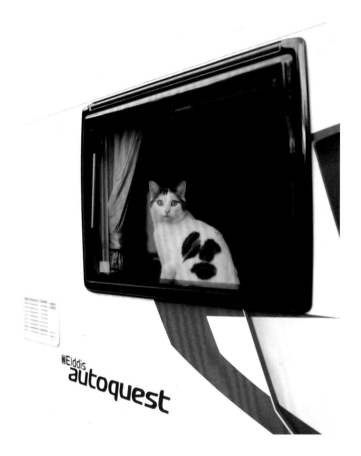

Dunstan Hill, Northumberland

Danny Francis
Van life 5 years
Driving Bailey Pageant

'I am training to be a ninja,
so I like making weapons
out of sticks.'

Beddgelert, Snowdonia

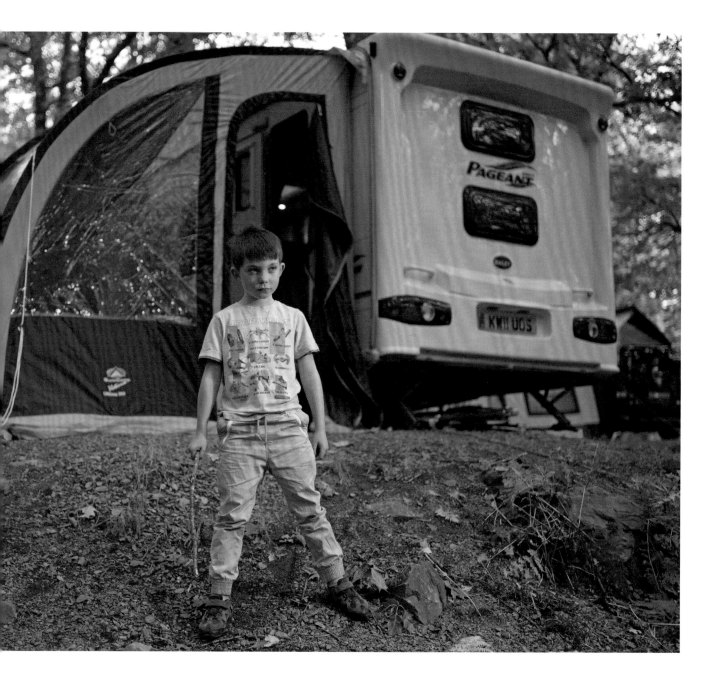

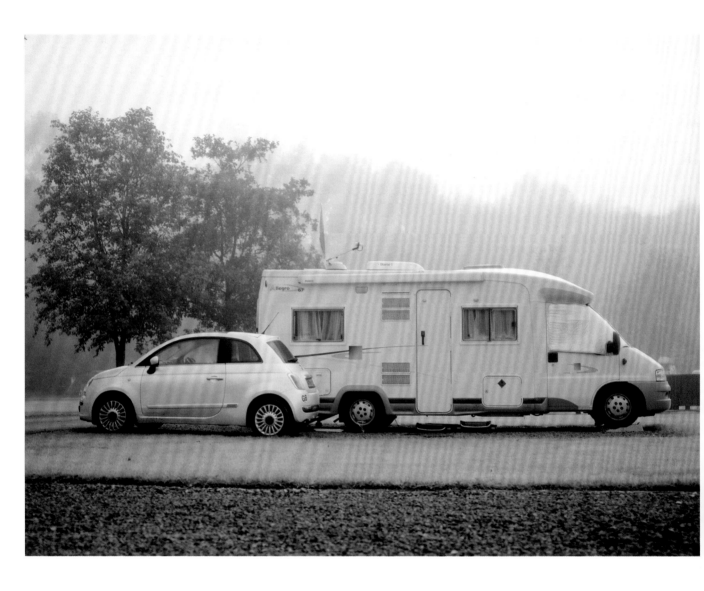

Rhandirmwyn, Carmarthenshire

Keswick, Lake District

Glencoe, Argyll

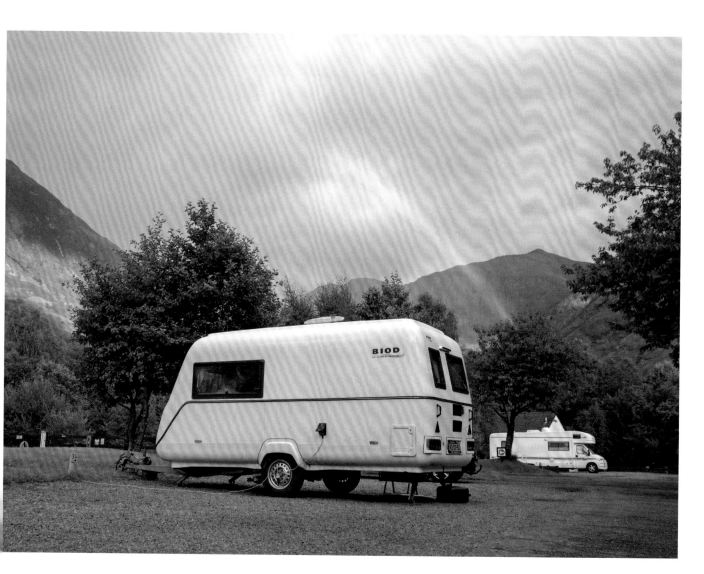

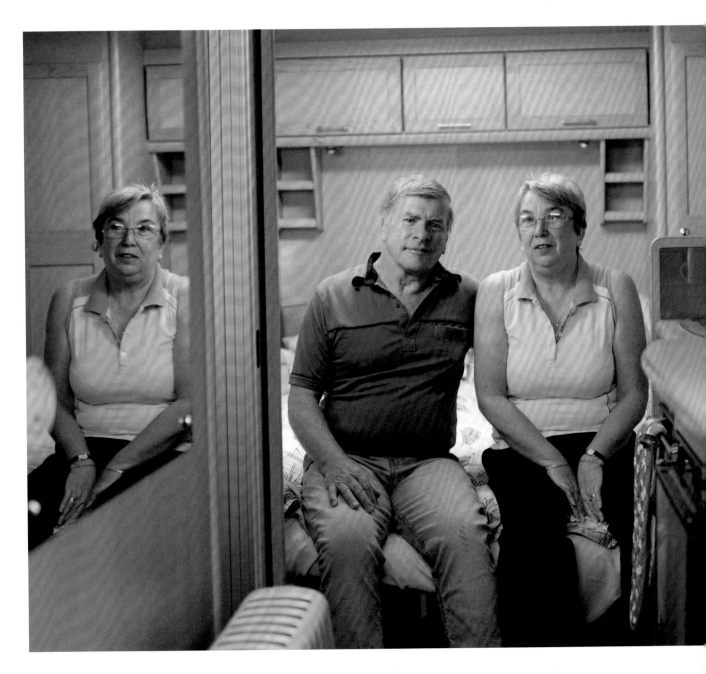

Elaine and Peter Williamson
Van life 35 years
Driving Elddis Odyssey 550

'One of my best memories is the time I woke up to find a deer staring into the window. We looked at each other for a moment before he bolted – it was very special. The worst time was when we were caught in the hurricane of 1987, caravanning on a cliff.'

Elaine

Luss, Loch Lomond

Delamere Forest, Cheshire

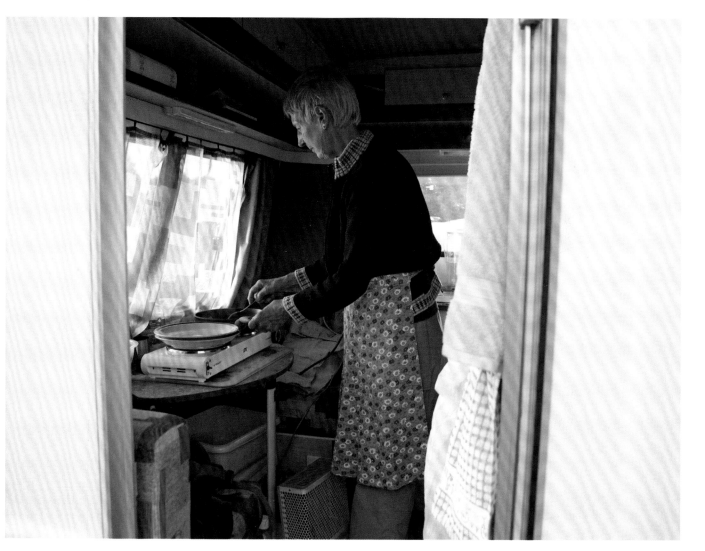

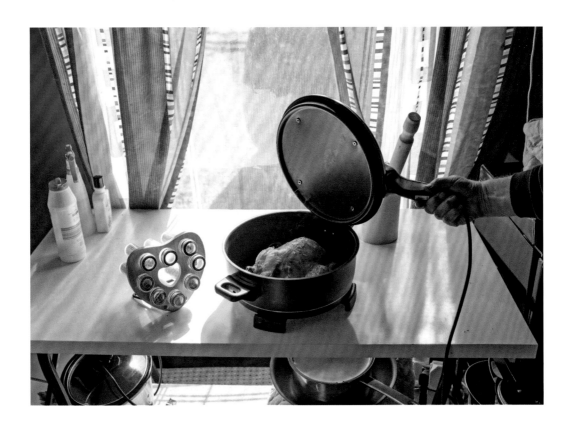

Braithwaite Fold, Lake District

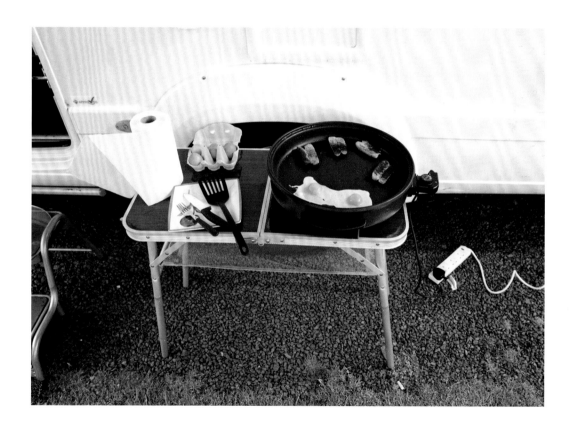

Lauder, Scottish Borders

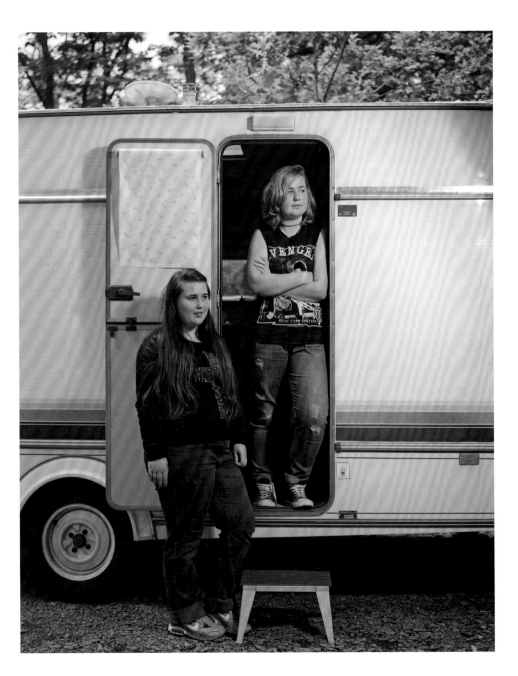

Megan and Lily Bradford
Van life As long as we can remember
Driving Elddis

'My parents used to own an old VW T2. There was no heating so we'd sit in the back with a huge blanket. And someone would be on hubcap duty while we were driving – if the hubcap fell off, you had to yell out and then go grab it.'

Megan

Beddgelert, Snowdonia

Rhandirmwyn, Carmarthenshire

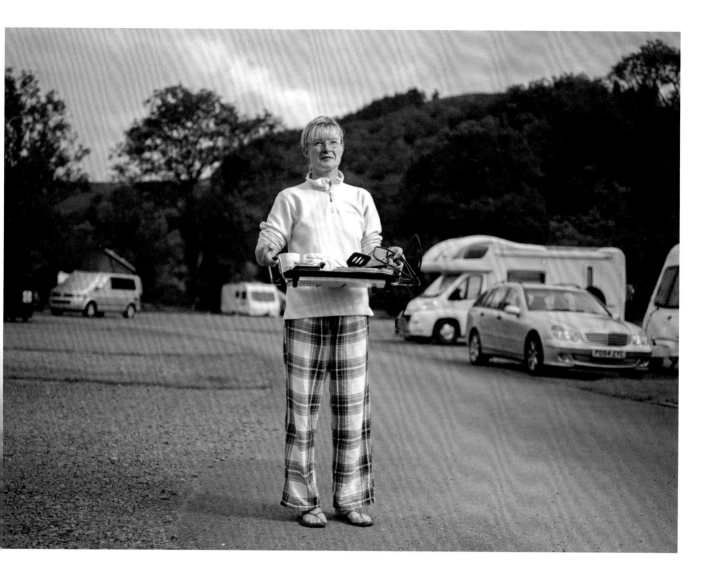

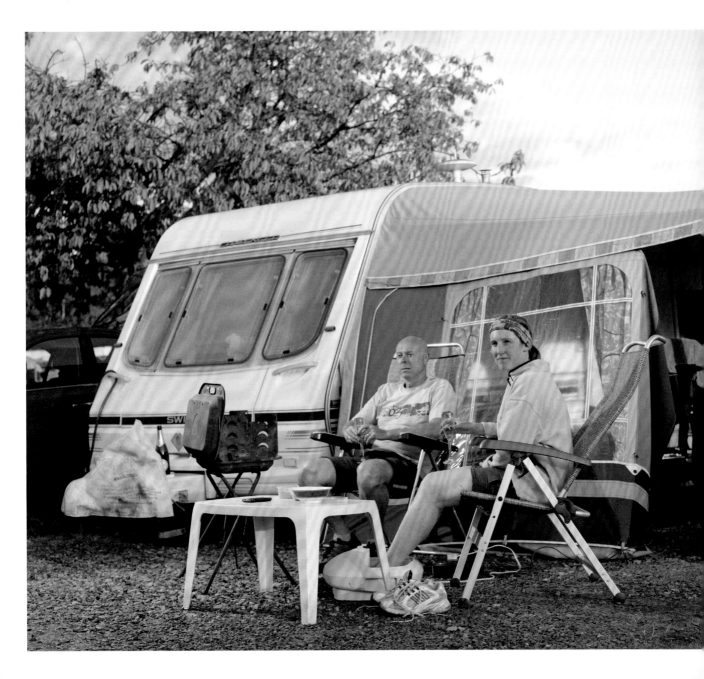

Andrew and Jackie Turpin
Van life 22 years
Driving Swift Challenger

'Every time we caravan, we have to bring the foot spa, barbecue, wine, nibbles and a good sense of humour. We've been stuck in mud and blown the electrics, and we brought the M20 to a standstill once when the caravan fishtailed and we ended up facing oncoming traffic. But we love the outdoor lifestyle. We're from London, so coming here gives our kids freedom to ride their bikes and make friends.'

Jackie

Keswick, Lake District

Teversal, Nottinghamshire

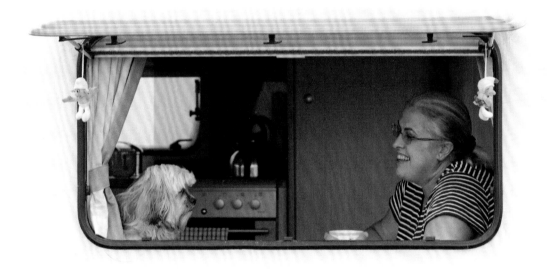

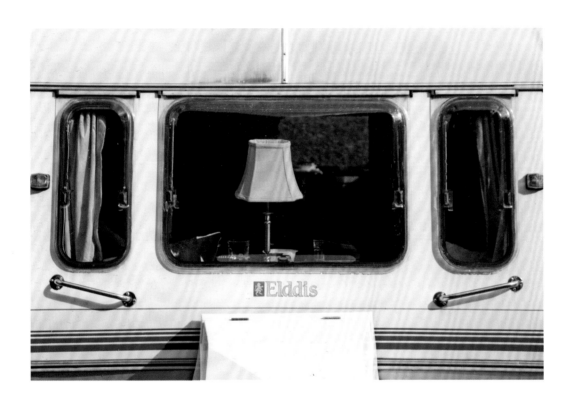

Glenmore, Cairngorms

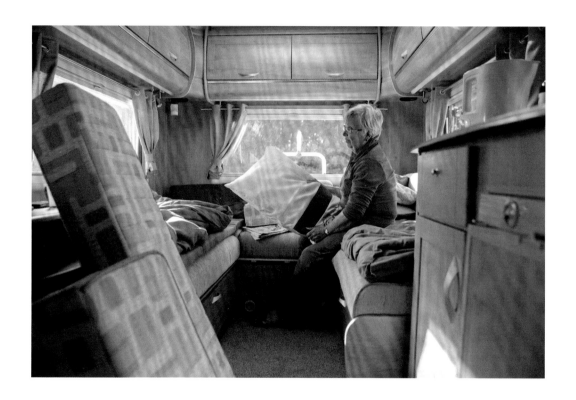

Delamere Forest, Cheshire

Steve Birch
Van life 35 years
Driving Swift Challenger

'Caravanning is a lifestyle. This year,
we set off in March and won't be
home until September.'

Delamere Forest, Cheshire

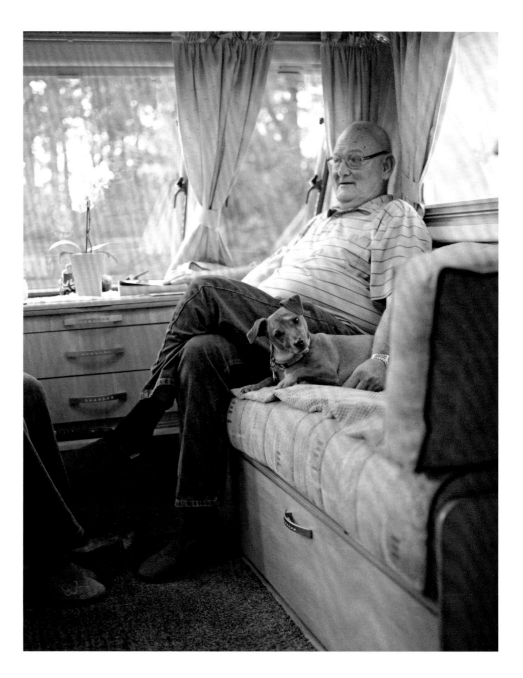

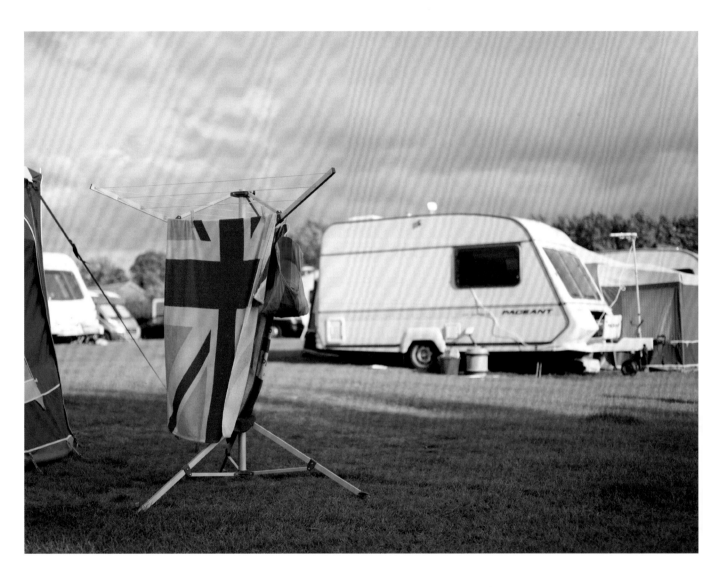

Dunstan Hill, Northumberland

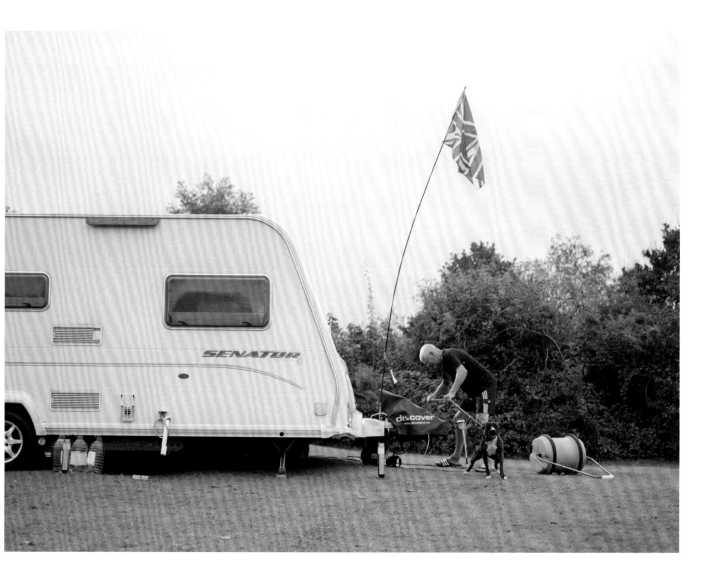

Ocknell, New Forest

Scarborough, Yorkshire

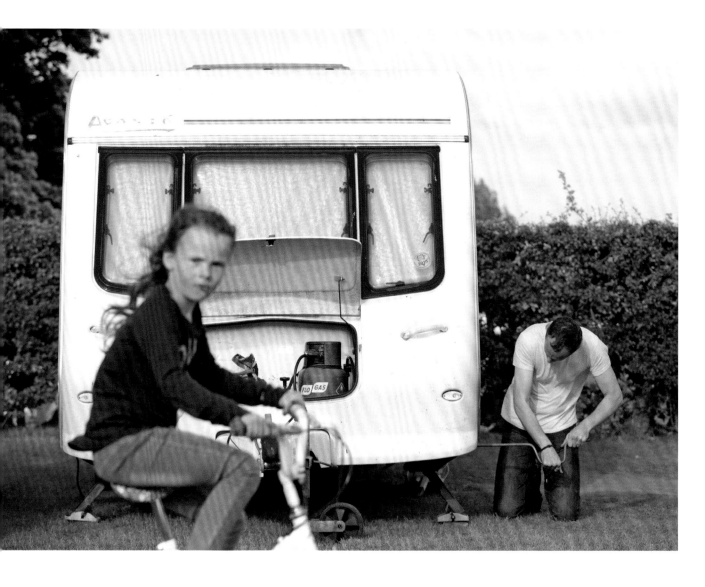

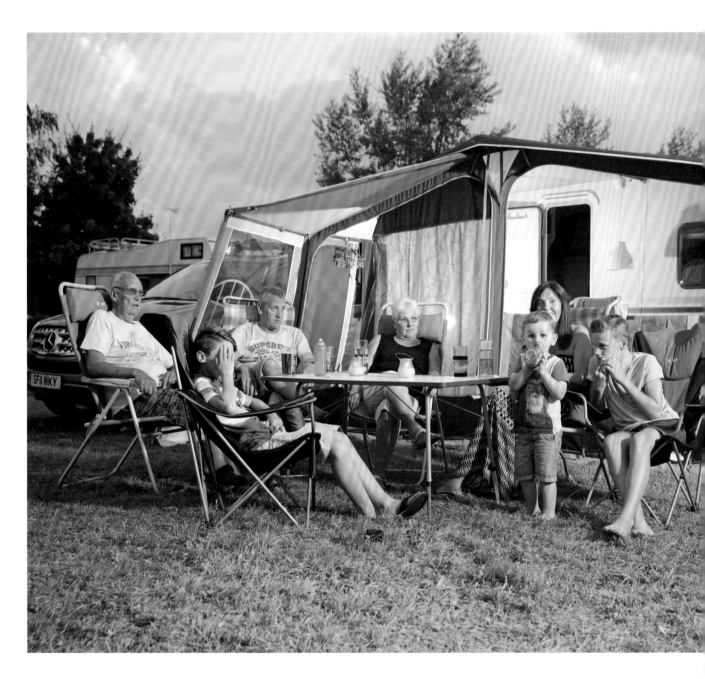

Devizes, Wiltshire

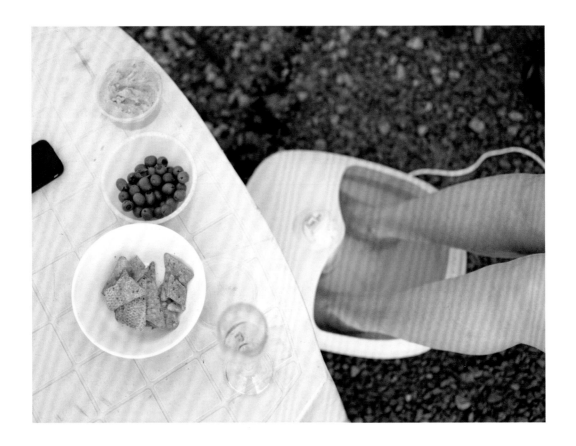

Keswick, Lake District

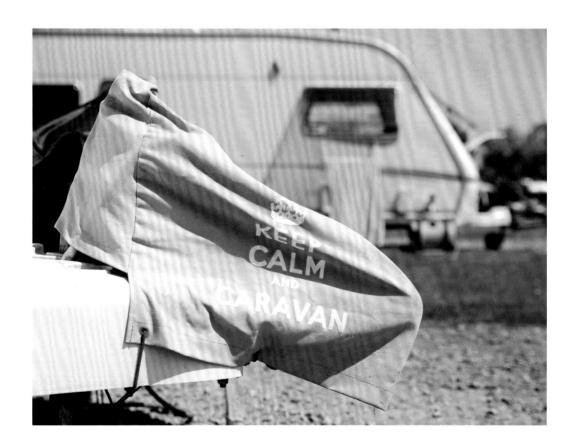

Walton-on-Thames, Surrey

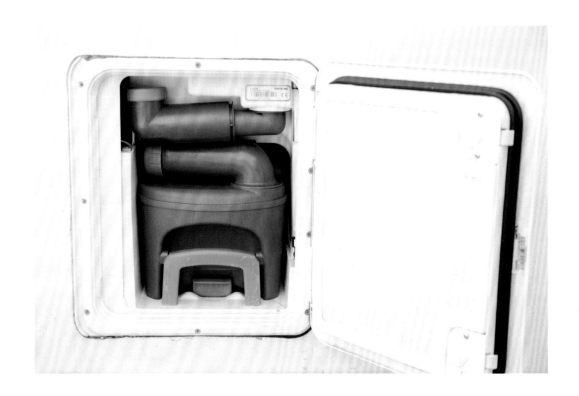

Oban, Argyll

Kelvedon Hatch, Essex

St Neots, Cambridgeshire

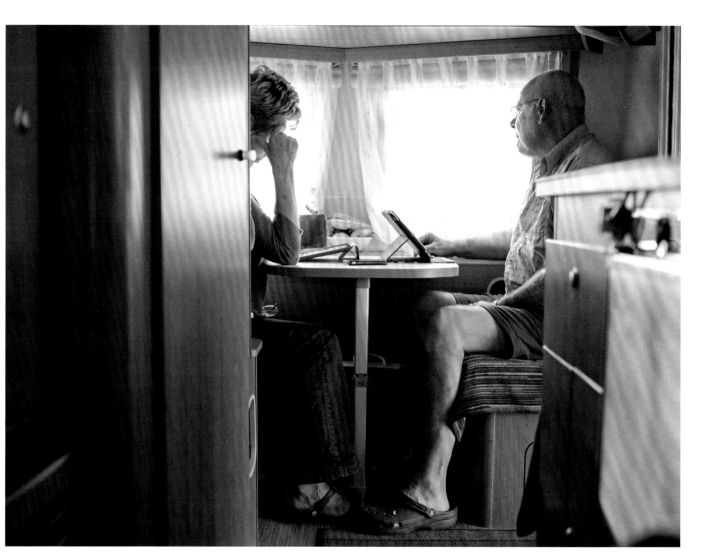

Judith and Terry Hill, Melanie and Rob Nicholas
Van life 20 years
Driving Auto-Trail Apache and Swift Lifestyle

'We've had some disasters, like the time we drove up a mountain in Portugal and realised we couldn't go any further and we couldn't turn around. But we get to meet up with our friends every year, sit outside even if it's cold and see places we wouldn't otherwise visit.'

Judith

Delamere Forest, Cheshire

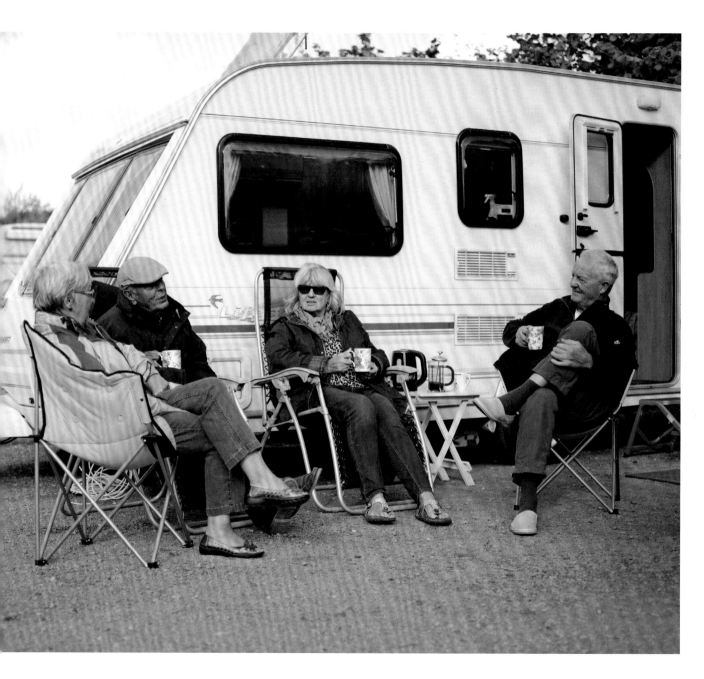

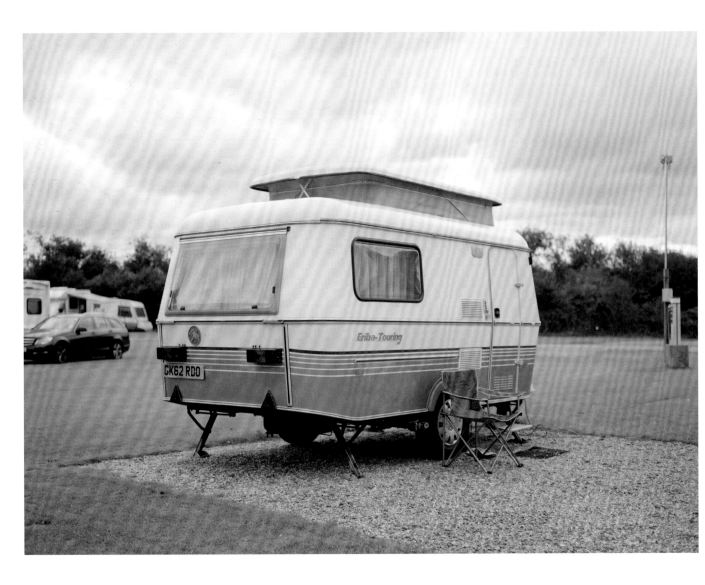

St Neots, Cambridgeshire

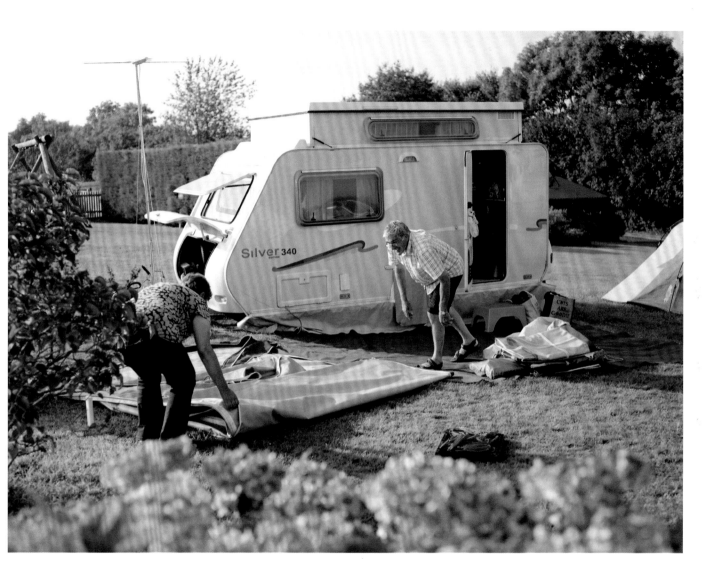

Teign Valley, Dartmoor

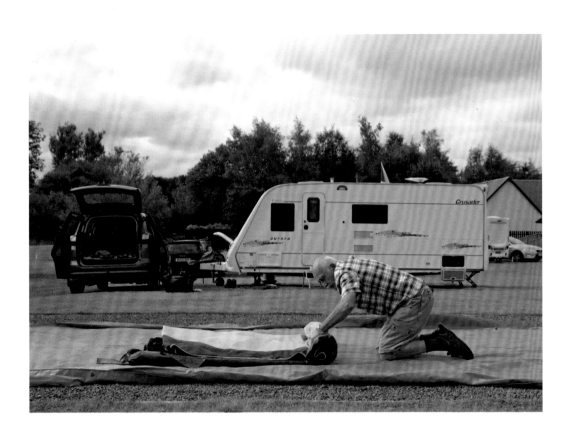

Lauder, Scottish Borders

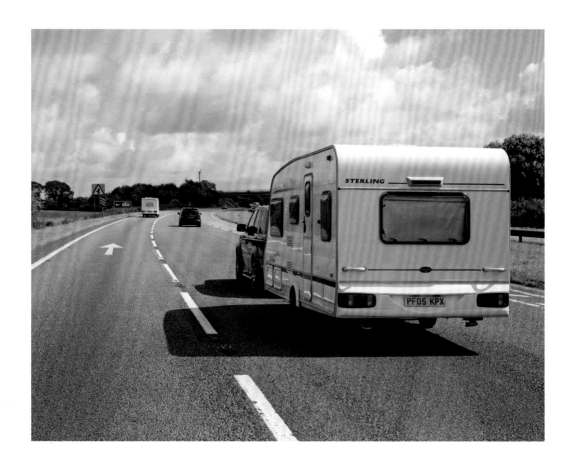

A55, North Wales

M6, Morecambe

Ocknell, New Forest

ACKNOWLEDGEMENTS

I'd like to thank...

The Camping and Caravanning Club, particularly
Kimberley Keay and Rob Ganley for helping to
bring my trip together and facilitating my time on
so many of the brilliant club sites.

My wife Kimberley Willis for the huge amount of
support and help and agreeing to drop everything
and live in a motorhome with me for 27 days.

My commissioning editor Zena Alkayat for believing
in the project and being incredibly enthusiastic about
it right from the beginning.

Glenn Howard for his excellent work on the design
and layout of the book.

A special thanks to all the wonderful people I met
and photographed along the way. I couldn't have
dreamed of receiving such a warm welcome – I was
truly bowled over by the friendliness and openness
of the caravanning community.